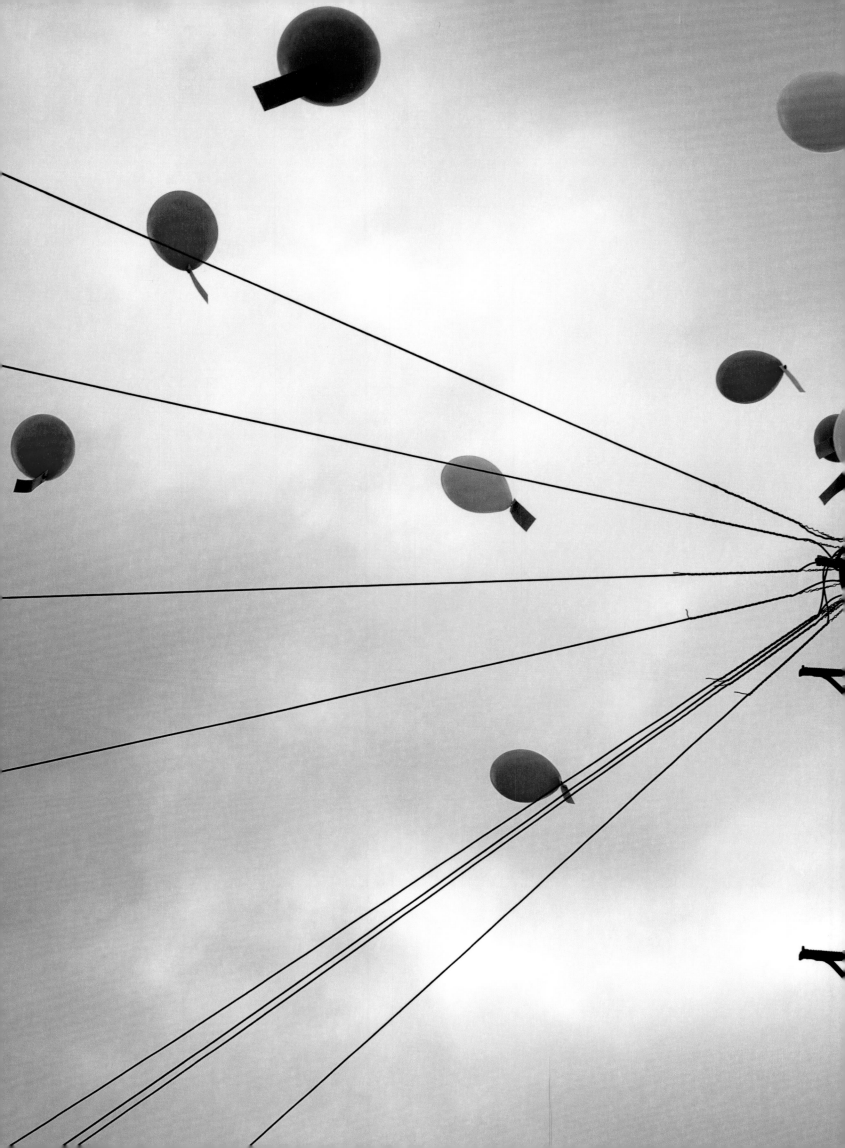

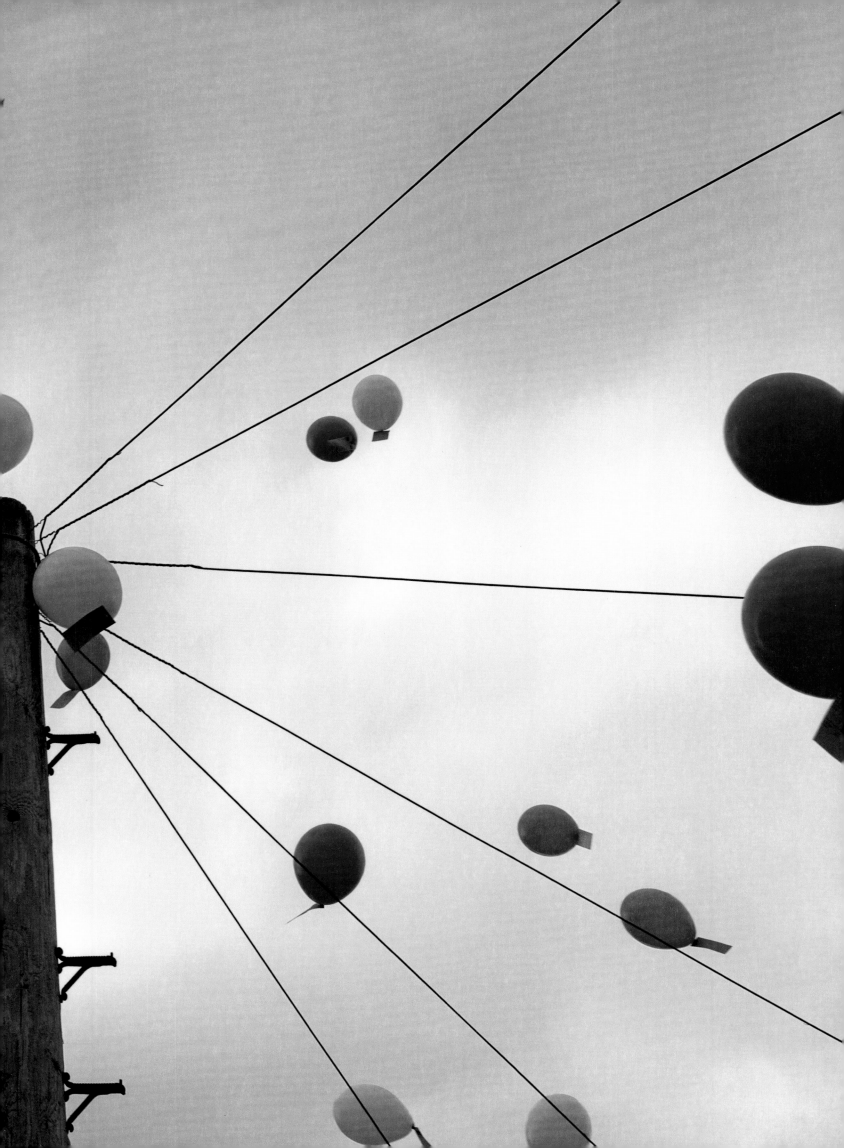

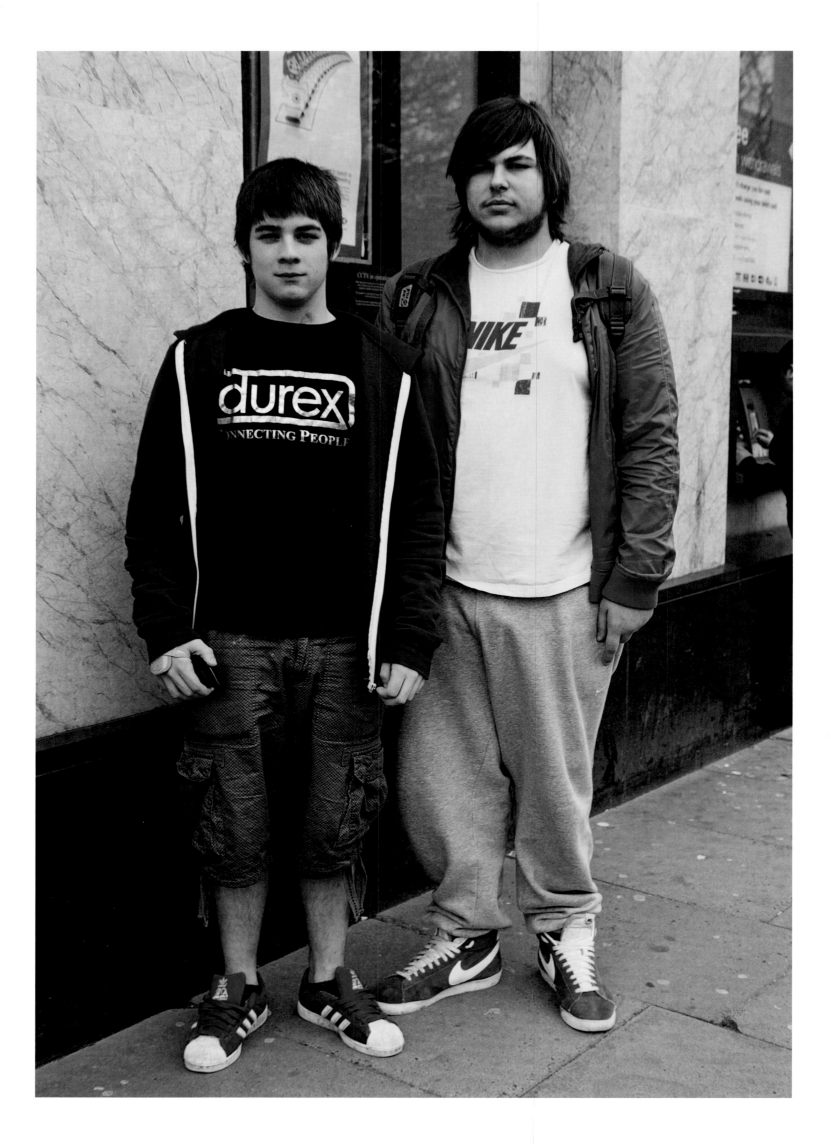

BLACK COUNTRY STORIES

MARTIN PARR

DEWI LEWIS PUBLISHING

Previous pages:
Royal Wedding street party, Hobart Drive, Walsall
Ben Reeves (left) and Sean Smith (right), Sandwell College students

Black Country Thoughts

When Emma Chetcuti of Multistory sent me an email over four years ago, inviting me to work in the Black Country, little did I know what profound repercussions it would have on my working life as a photographer. I didn't really know much about the Black Country, other than its reputation as a densely populated, post-industrial area; a region in decline. I had passed it many times as I travelled up the M5, on my way north. My ignorance was one reason why I was keen to explore, and to try and look beyond the stereotypes.

Many of the industries that once made the Black Country great have indeed declined but numerous small factories and manufacturing businesses remain in good health. A degree of regeneration has come about due to the many immigrant communities that have made the Black Country their home. The region is populated with so many different communities – Polish, Sikh and Somali to name but a few – all bringing an energetic work ethic, a strong sense of family and culture and, in many cases, a profound religious faith.

These aspects of Black Country life, of course, were gifts for me as a photographer. I explored workplaces, temples, churches, shops, clubs and societies. Wary of neglecting the day-to-day experience, I also photographed in the Merry Hill Shopping Centre, in shops such as Tesco and in leisure facilities such as gyms, sports centres and spas.

The collaboration with Multistory started late in 2009, with a photography commission in the Sandwell area (six towns, if you are not familiar with the Black Country, made up of Oldbury, Rowley Regis, Smethwick, Tipton, Wednesbury and West Bromwich). The work was shown just a year later at The Public, in West Bromwich, in November 2010.

As well as the main exhibition on the top floor of the gallery, which comprised 25 prints of the best images, we decided to display a collection of 668 images, as 10 x 8 inch prints, on the ground floor. The purpose of this was two-fold: firstly, more local people would feature in, and be likely to engage with, the exhibition and, secondly, the prints would form a photographic archive which would accrue value in years to come, as an authentic documentation of Sandwell in the early 21st century.

I remember very well the opening of the Sandwell exhibition. We invited the many people who appeared in the photographs to come early and have a preview of the show before the main crowd arrived. It was very rewarding and exciting to see their reactions. Many had never visited The Public before, let alone seen an exhibition that they themselves featured in.

Alongside the photographic project, we realised that it was essential to gather oral histories from some of the fascinating people I had met whilst out shooting – from pigeon fanciers to members of the Polish community celebrating their traditional Easter. The oral histories were also archived, as part of the legacy of the project.

Importantly, the Black Country work also inspired me to return to making films, as one of the most effective ways of capturing the Black Country stories I was coming across. In the first year of shooting in 2010, I visited the wonderful Teddy Gray's sweet factory in Dudley. Standing in the factory, with its lingering aroma of Teddy Gray's famous herbal tablets, I watched the workers as they started to roll out rock for their regular Dudley Zoo order. The whole process was hypnotic, as the letters were assembled and the rock rolled back and forth, with perfect co-ordination between the team members. I knew immediately that the only way to do this remarkable factory justice was to make a film.

Six months later we did just that. The film of Teddy Gray's sweet factory was soon followed by three others: *Mark goes to Mongolia*; *Tudor Crystal*; and *Turkey and Tinsel*. So a pattern was starting to emerge as I continued to shoot my way around the Black Country. The photographic archive and oral histories were now supplemented by a number of films, each producing distinctive, and yet complementary, narratives.

Perhaps the most striking feature of the Black Country, for me, was the friendliness and openness of the community. Virtually no-one turned down a request for a portrait. People were so welcoming, and seemed only too glad to share their stories. One person would pass me onto someone else, or onto another story. In fact, I could have gone on forever but, at some point, you have to sit down and try and make sense of all this accumulated material.

So that is exactly what this book is about, along with the show which accompanied its launch, exhibited at The New Art Gallery Walsall and Wolverhampton Art Gallery. As well as photographs covering different themes and topics, it includes many portraits, an aspect of my work that has really blossomed through this project. And, if you have the opportunity, you can engage with a different type of storytelling by watching the four Black Country films that I have made.

A box of archive prints, specific to each geographical area, has been given to Sandwell Metropolitan Borough Council; Walsall Metropolitan Borough Council; and Wolverhampton City Council who all supported the project, thus leaving a permanent record of my work in the area for generations to come.

My hope is that the abridged version of my four-year journey through the Black Country shown in this book will enable the sense of community and diversity and the spirit of the place to rub off on the viewer.

Martin Parr
May, 2014

All the photographs were taken between 2010 and 2014

Mark Evans, with No. 21, Pigeon Racing Club, Tipton

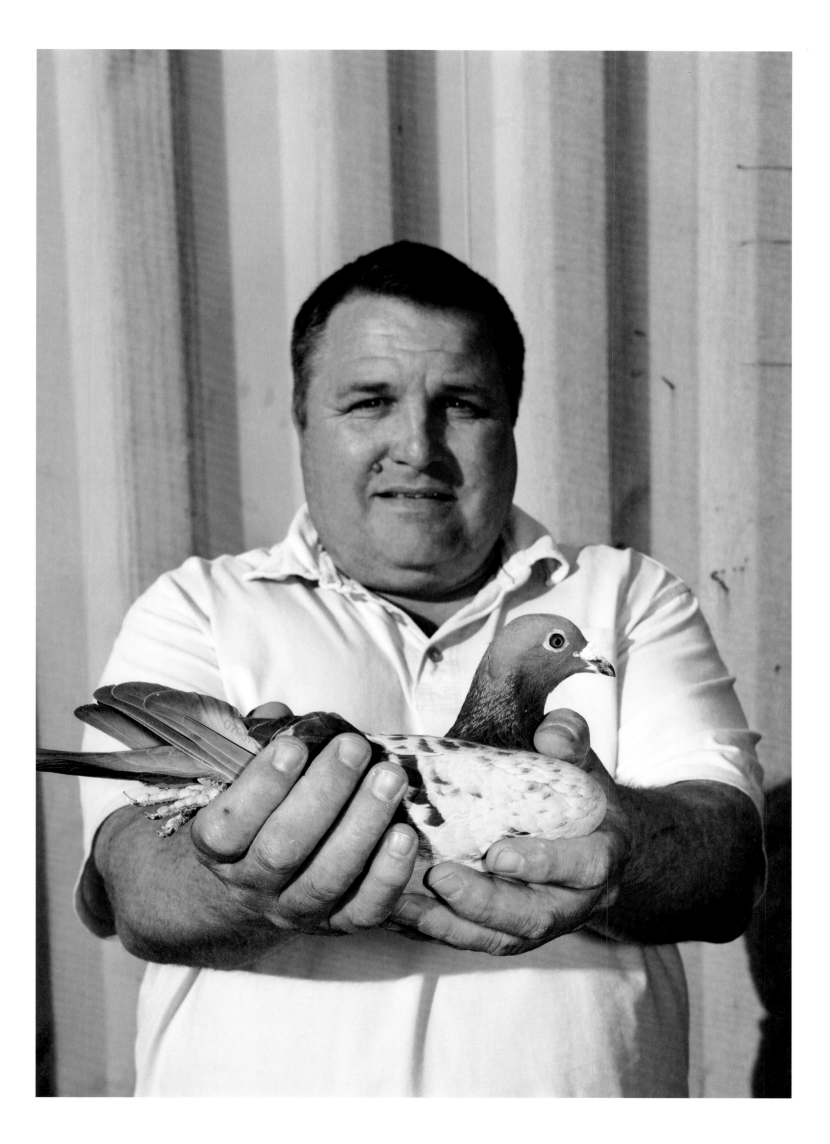

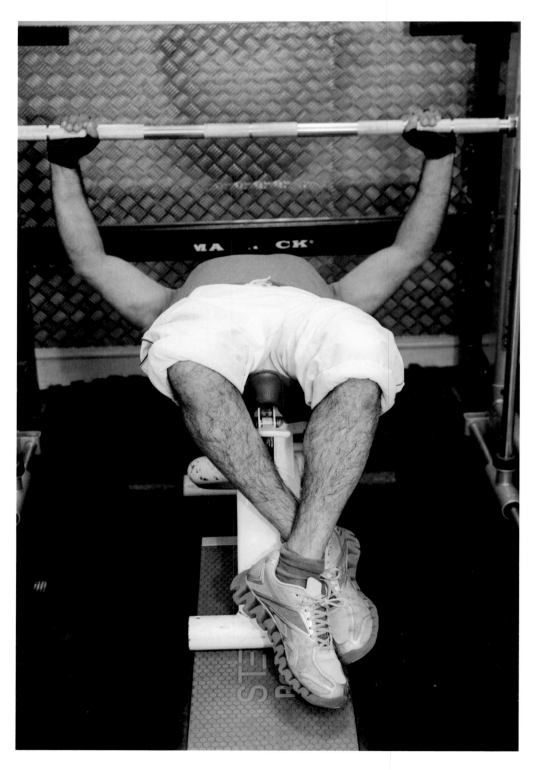

Velocity Health & Fitness, Village Urban Resort, Dudley

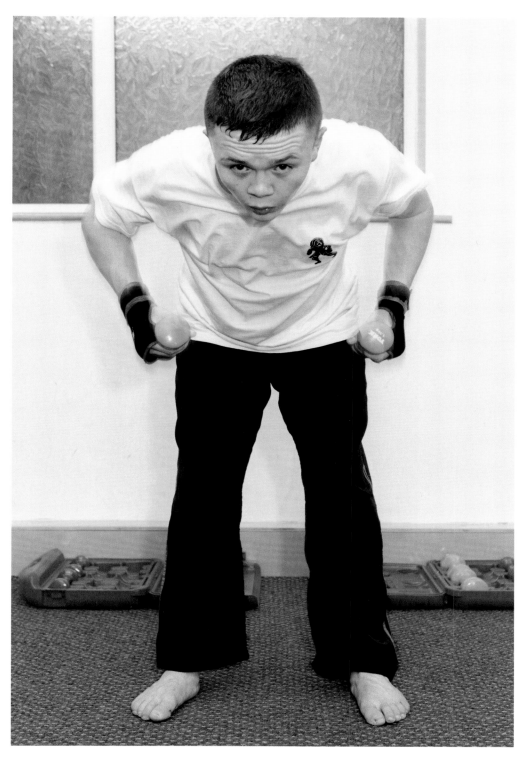

Pride Kickboxing, Chuckery Working Men's Club, Walsall

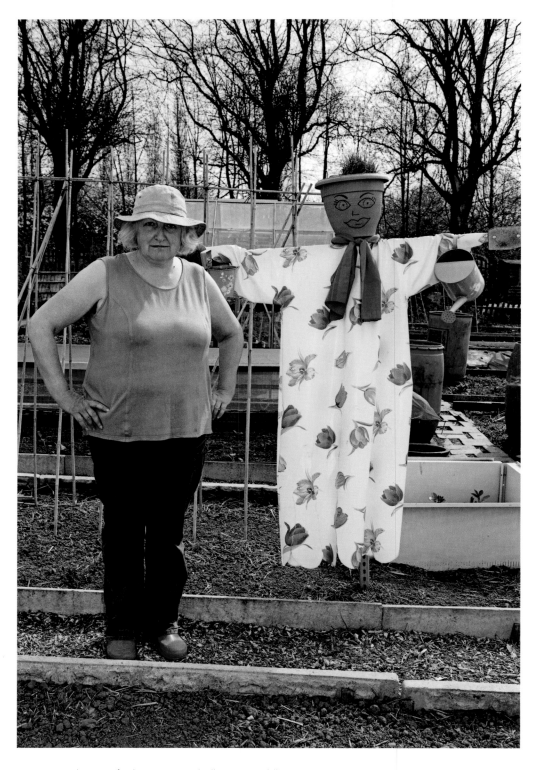

Annette Arculus, Barnford & Farm Road Allotments, Oldbury

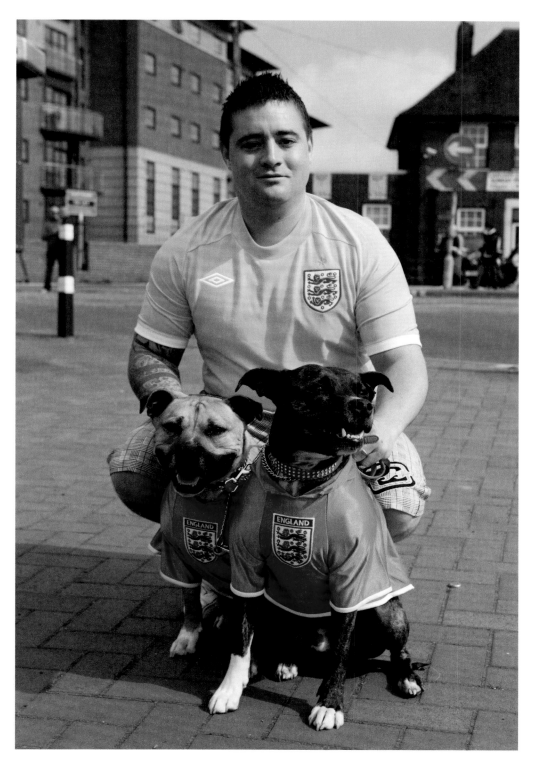

Daniel Horton with his Staffordshire Bull Terriers, St George's Day, West Bromwich

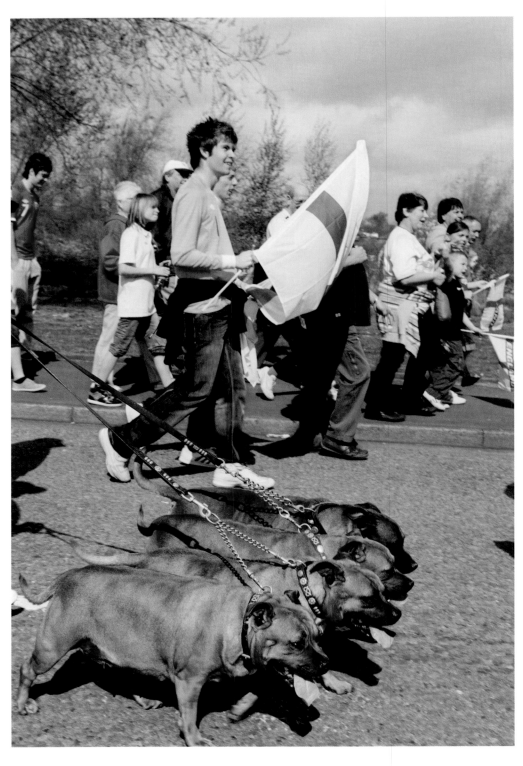

St George's Day Parade (the biggest in the UK), West Bromwich

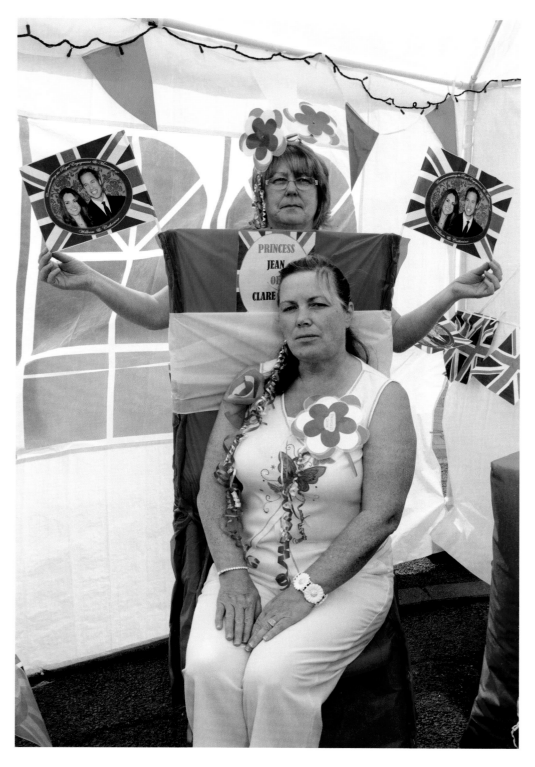

Jean Humpage, 'Queen of the Street', Royal Wedding street party, Walsall
Following page: Residents at the Royal Wedding street party, Clare Road, Walsall

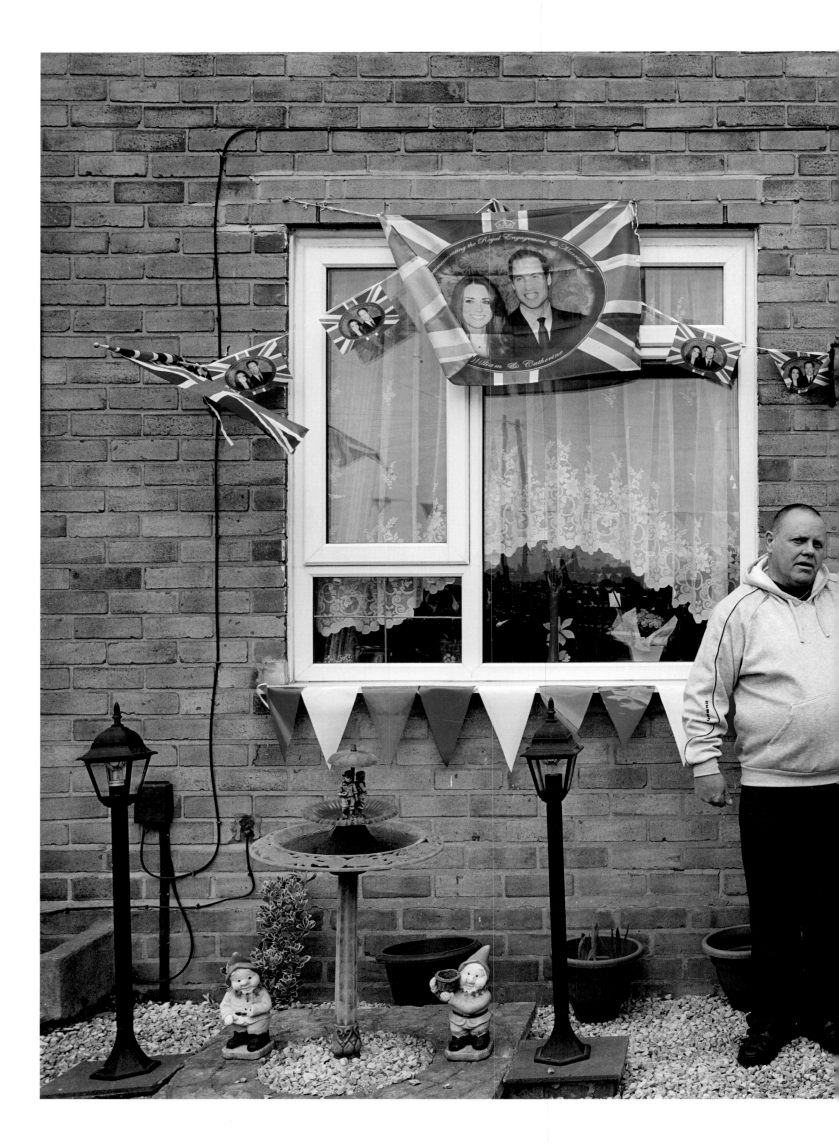

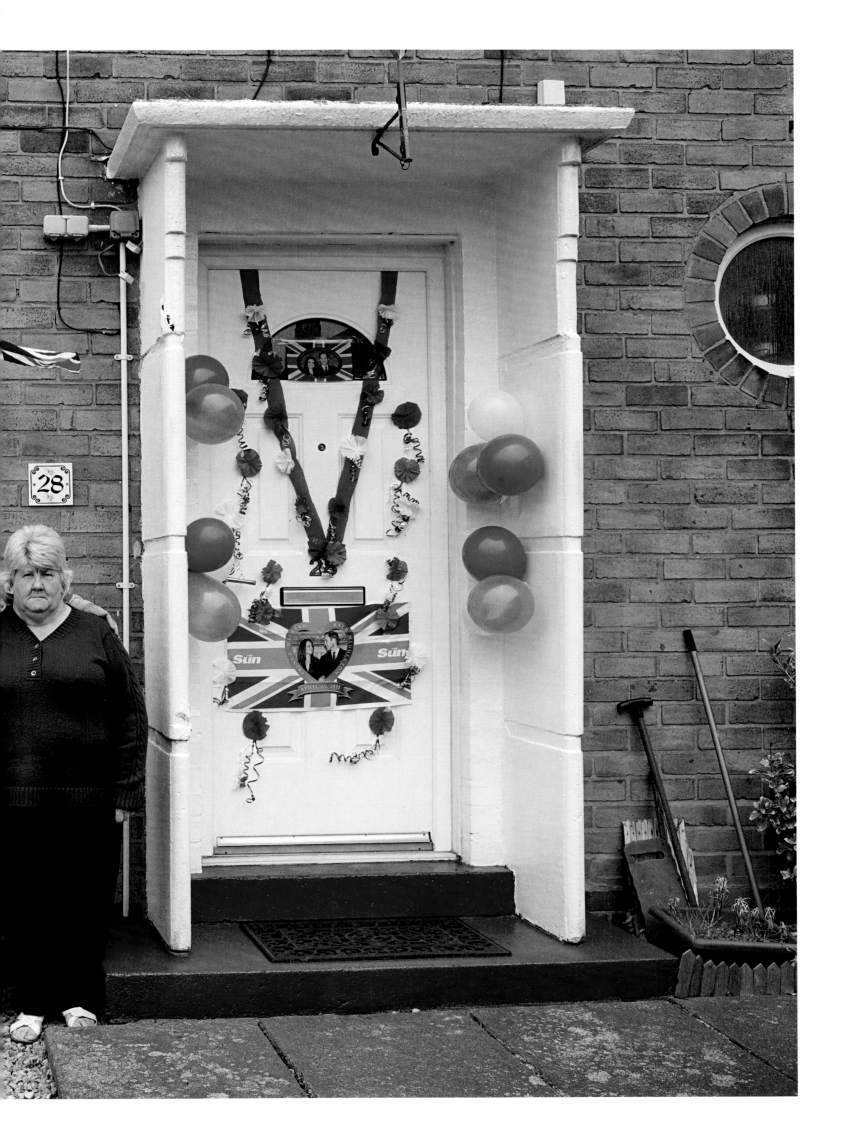

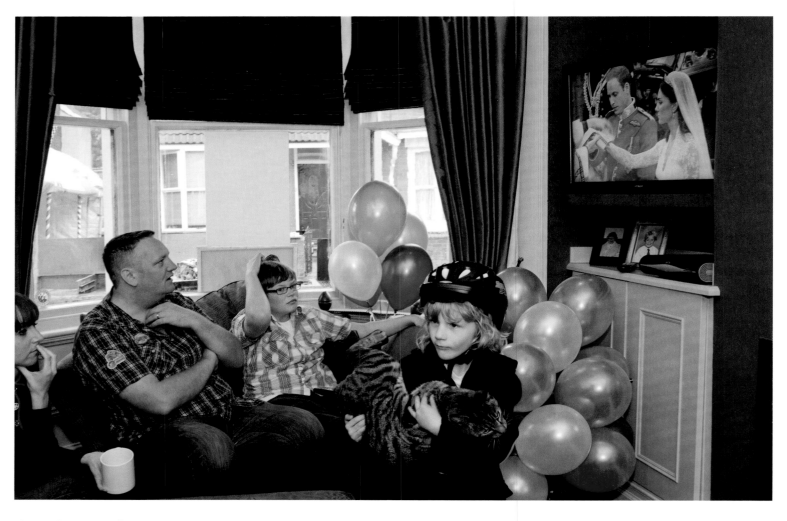

The Royal Wedding of Kate Middleton and Prince William, at home, Westbourne Street, Walsall

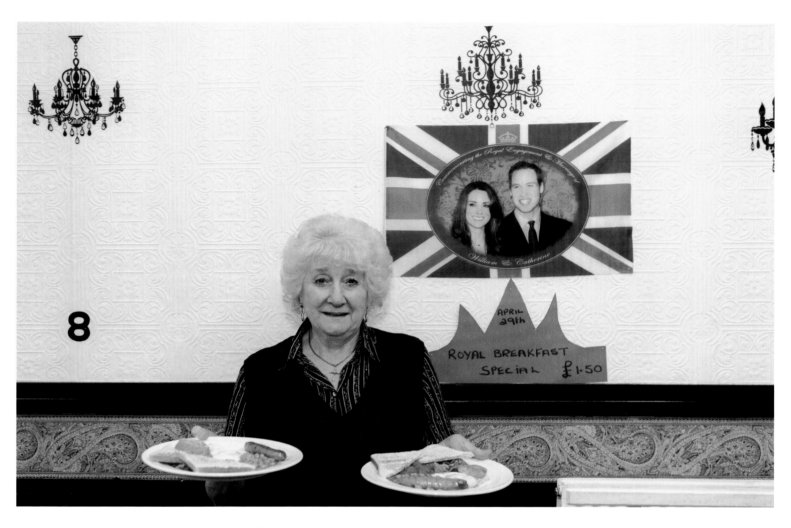

Royal Wedding breakfast special at Ginghams Café, Bilston
Following page: St George's Day party, Brook Street Community Centre, Tipton

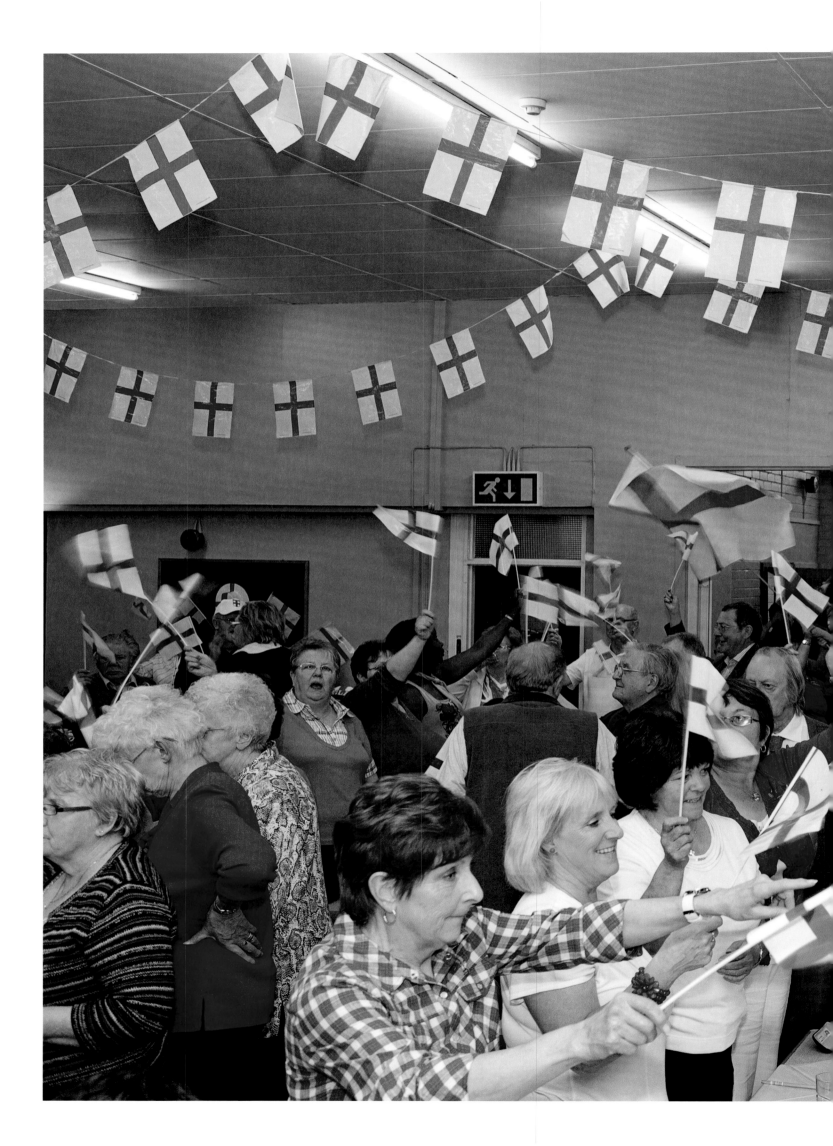

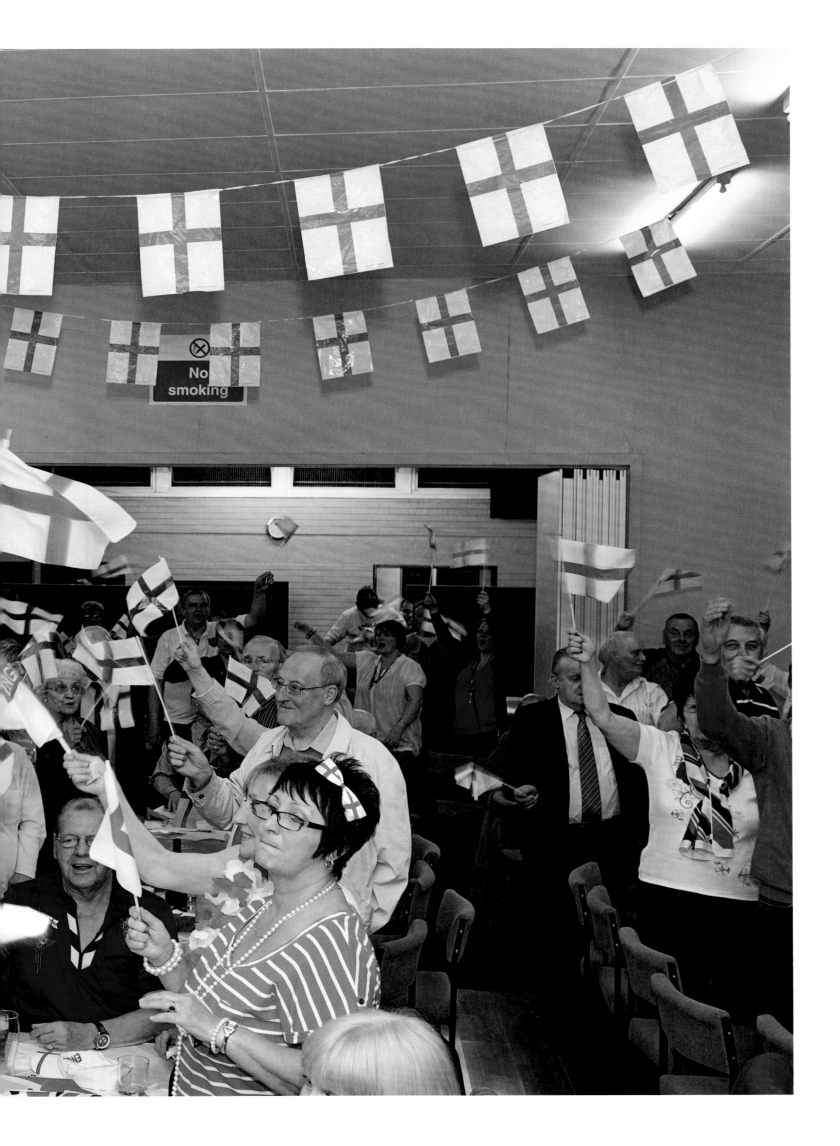

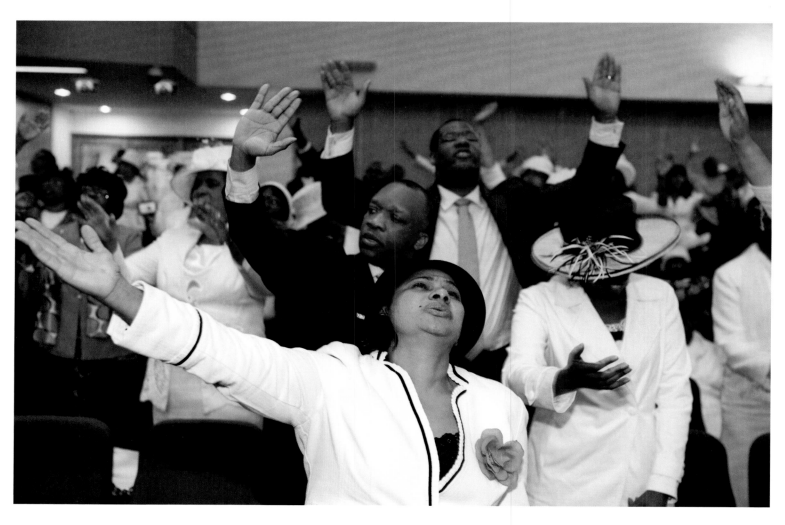

Ladies' Day at the Bethel Convention Centre, West Bromwich

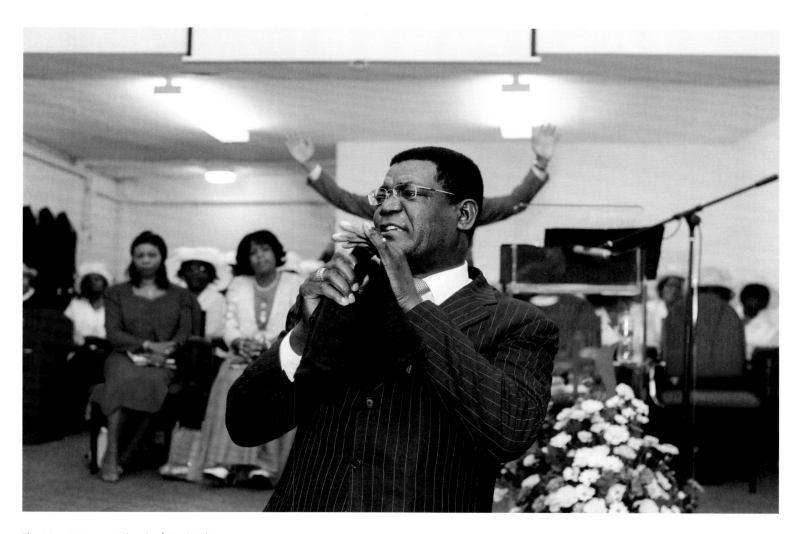

The New Testament Church of God, Bilston

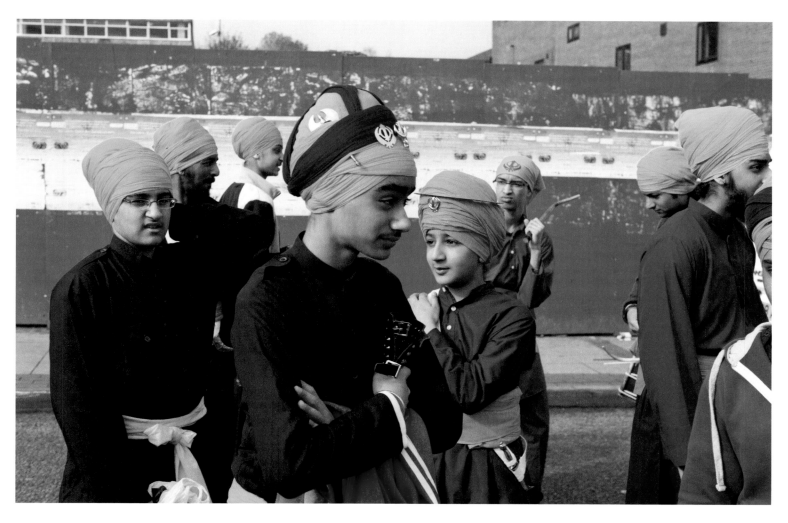

Vaisakhi, Guru Nanak Gurdwara, a Sikh temple, Smethwick

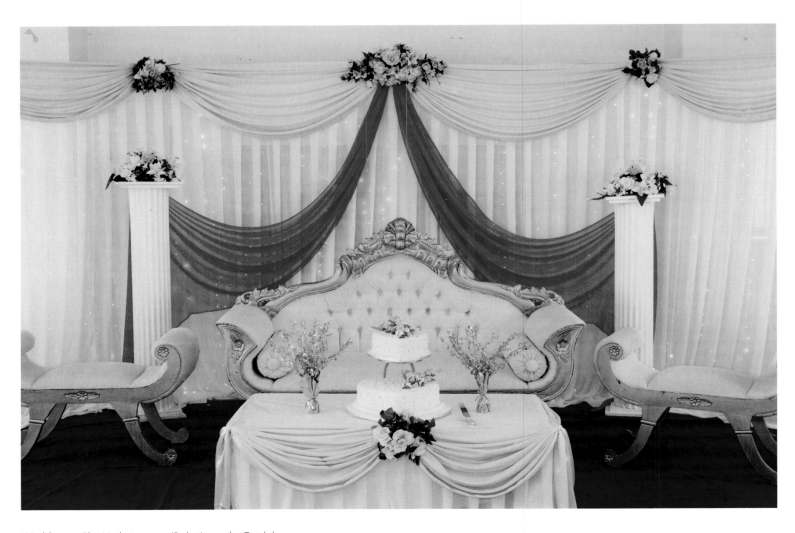

Wedding at Shri Venkatsewara (Balaji) temple, Tividale

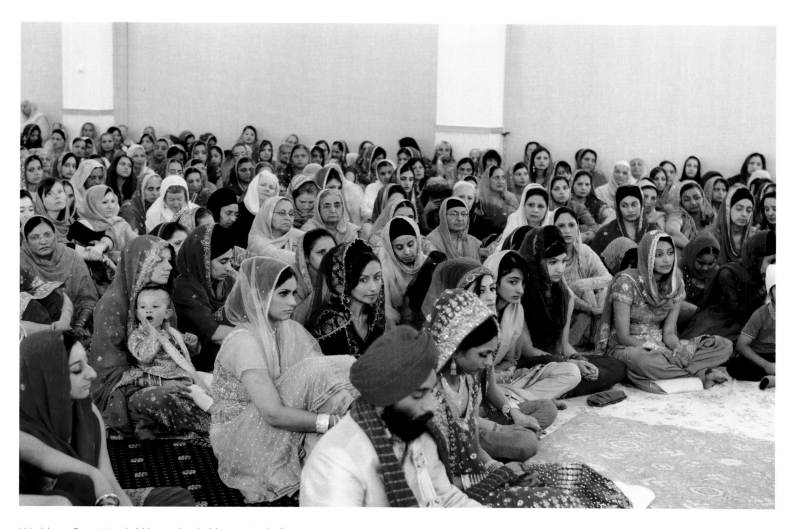

Wedding, Guru Nanak Sikh temple, Caldmore, Walsall

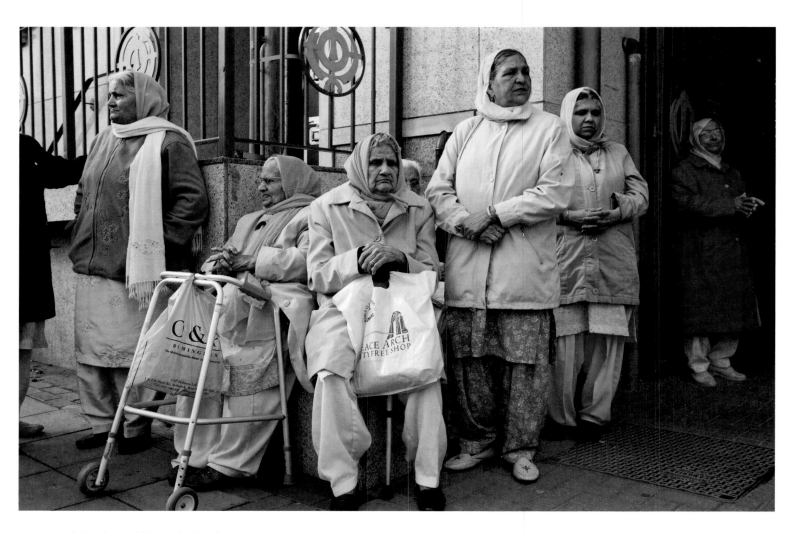

Guru Nanak Gurdwara Sikh temple, Smethwick

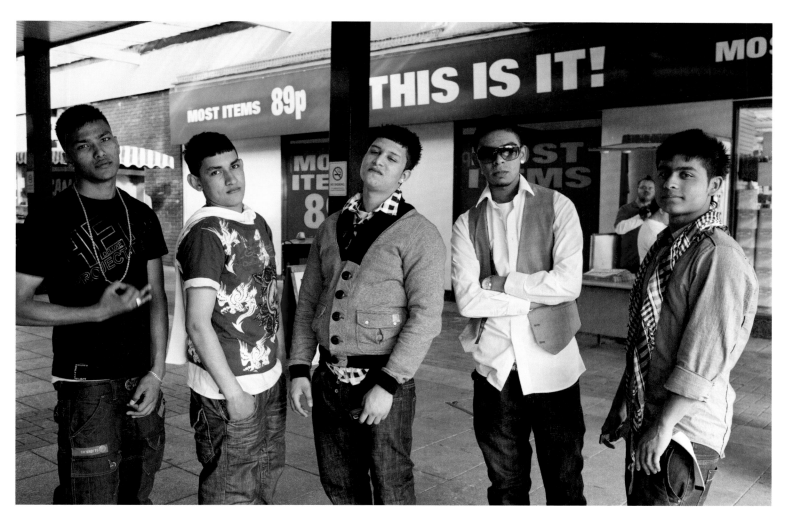

West Bromwich
Following page: Merryhill Shopping Centre, January sales, Brierley Hill

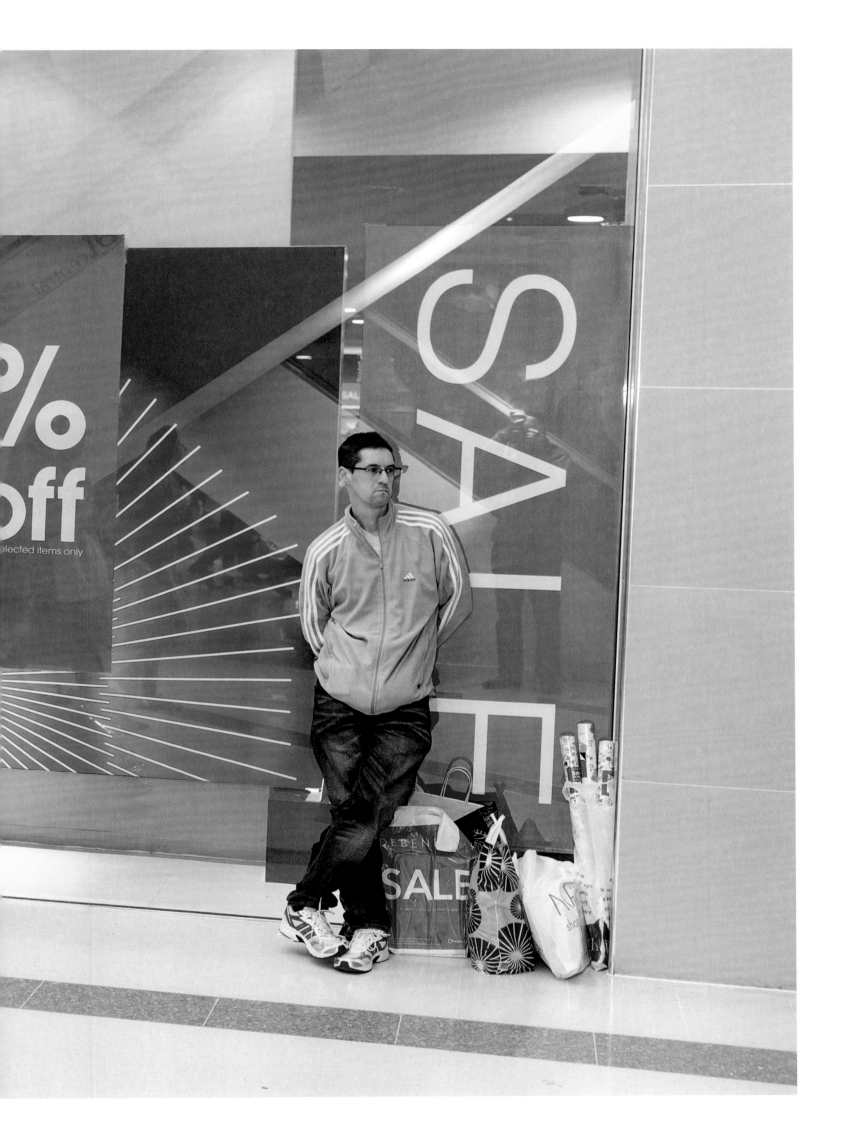

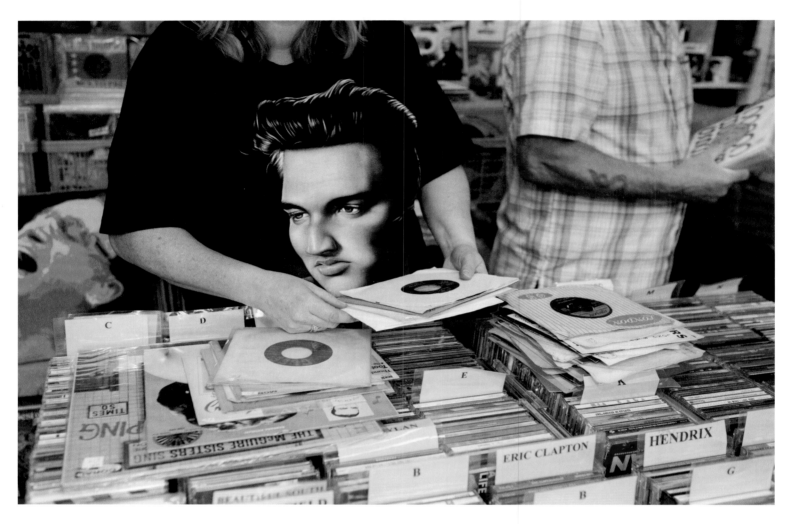

Bilston Market

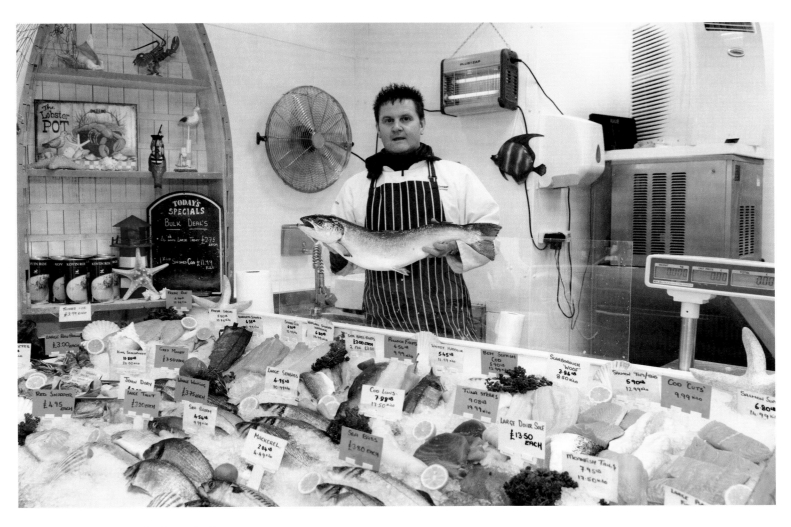

Mark Cooper, Ocean Seafood, Stourbridge
Following page: High Street, Walsall

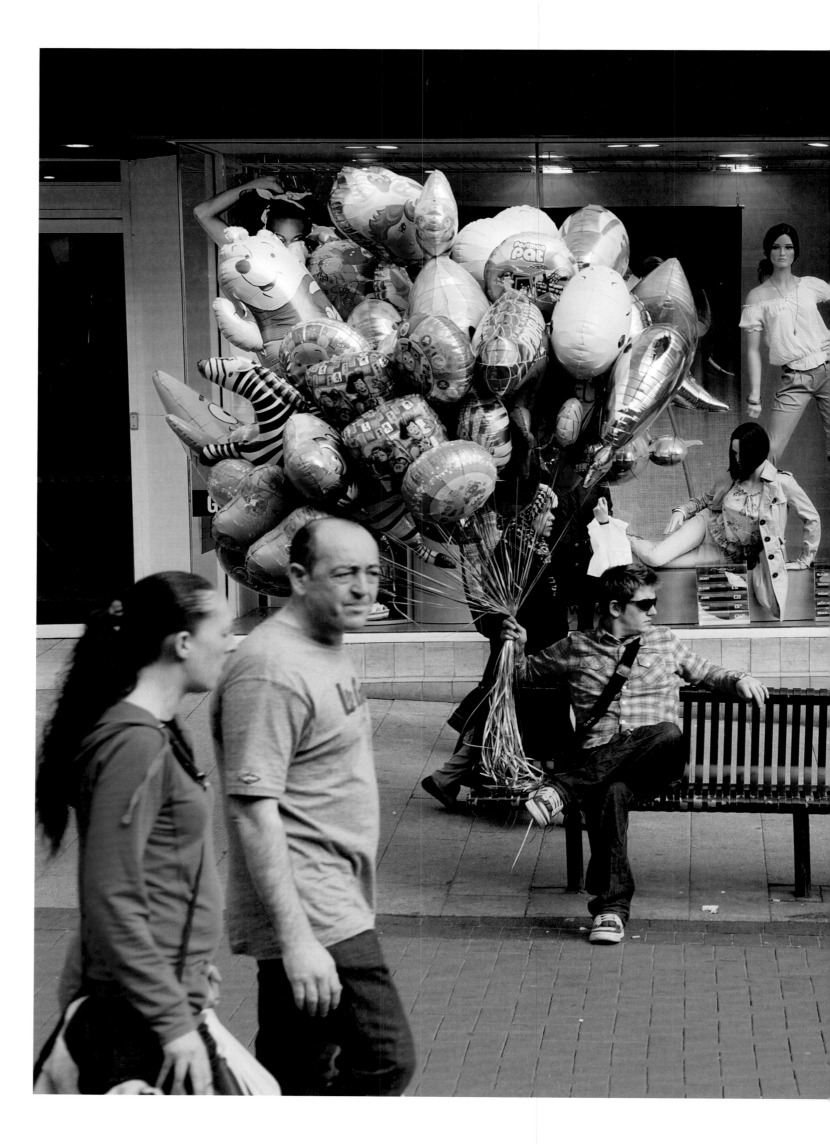

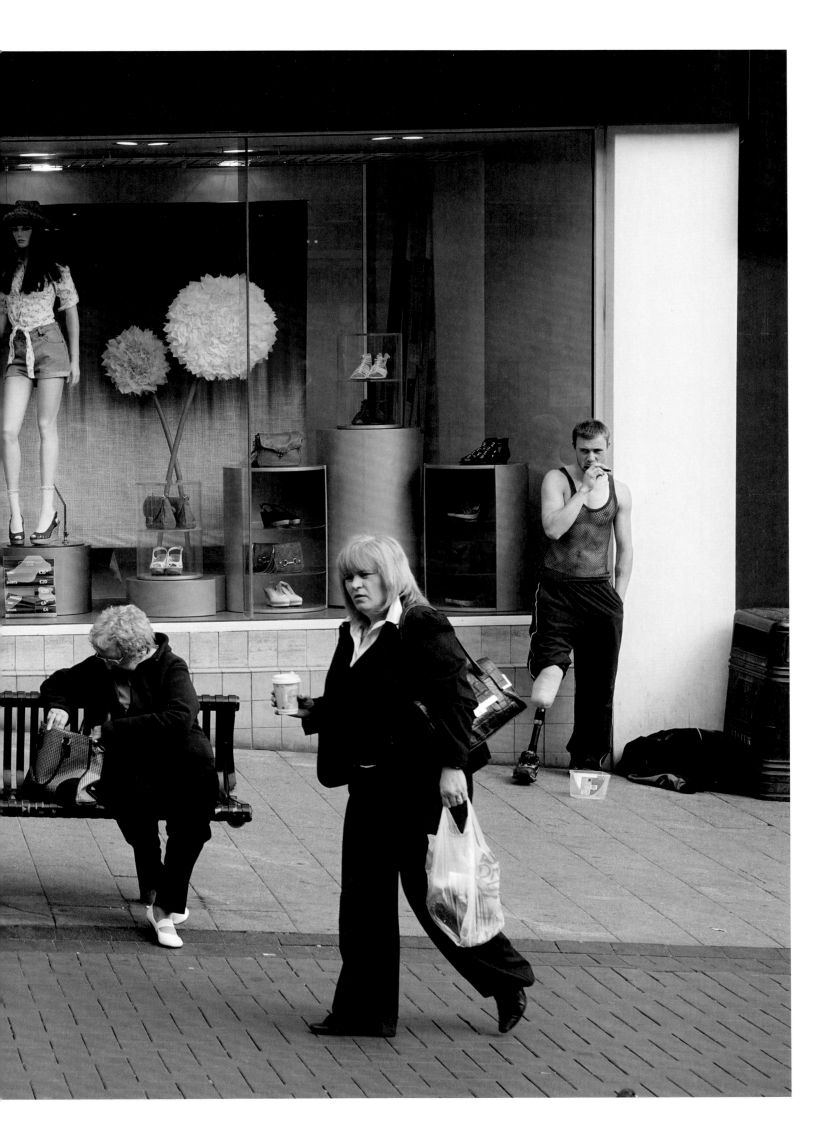

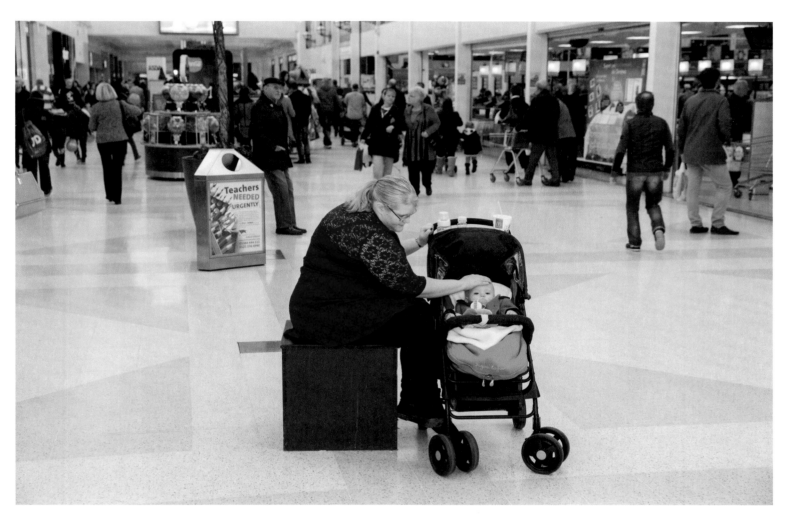

Merry Hill Shopping Centre, January sales, Brierley Hill

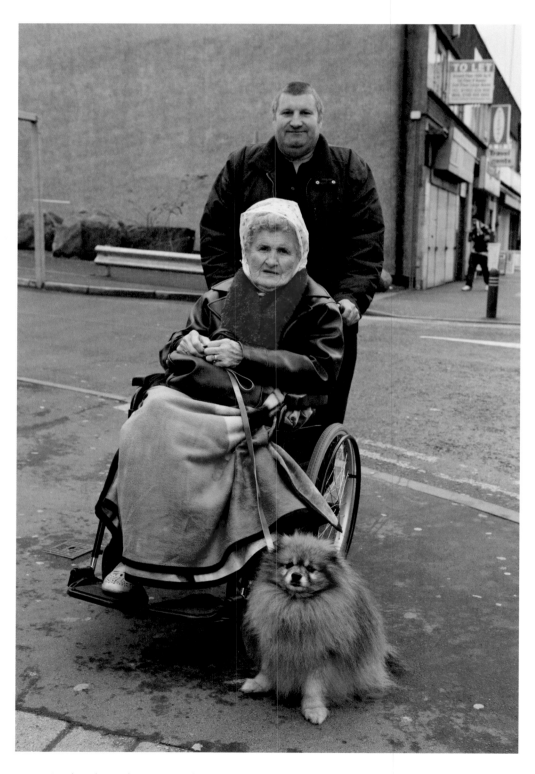

Davey Crochatt, his mother Joan Crochatt, & Sooty the dog, West Bromwich

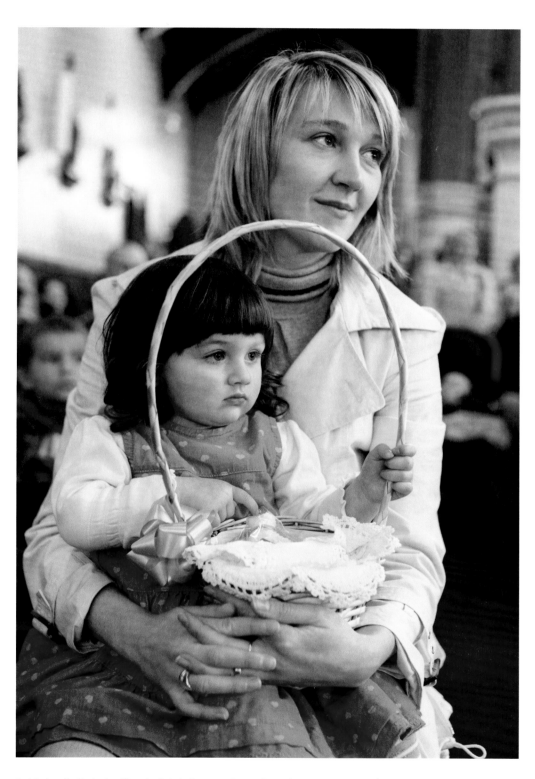

St Michael's Catholic Church, Polish Service, Easter Saturday, West Bromwich

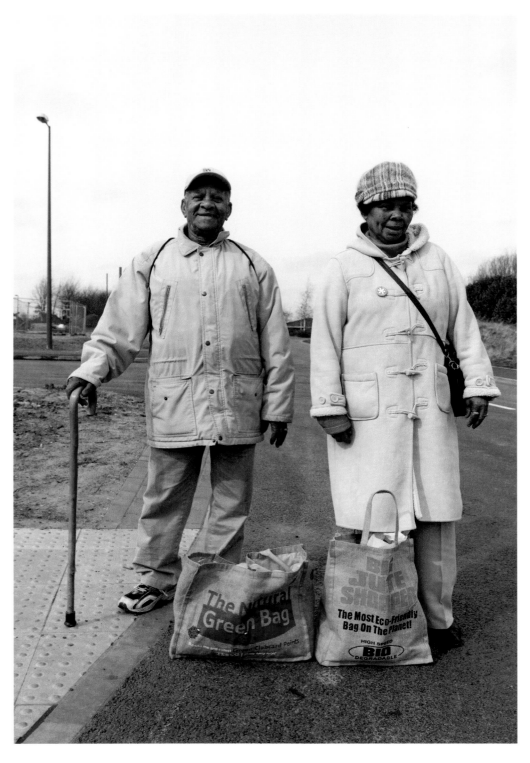

Arthur Crip & Kirsten Dolores, Tipton
Following page: Tootsies, fish pedicure, The Saddlers Centre, Walsall

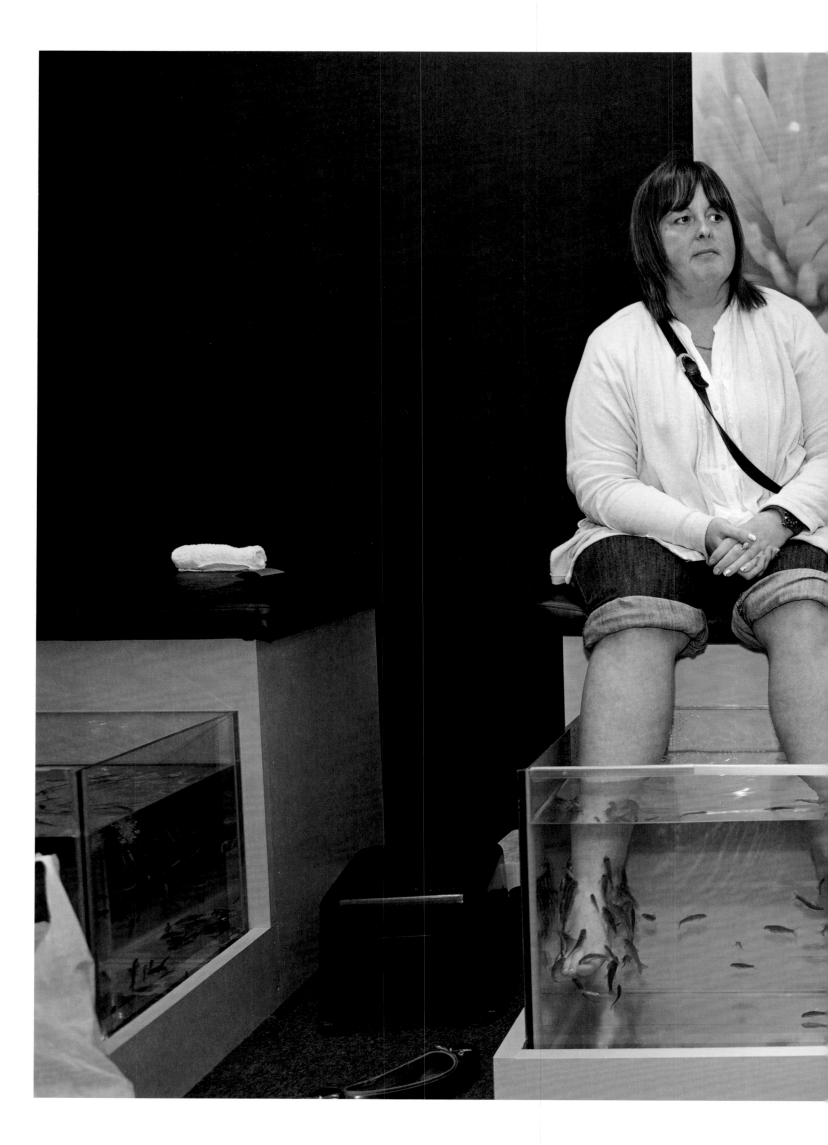

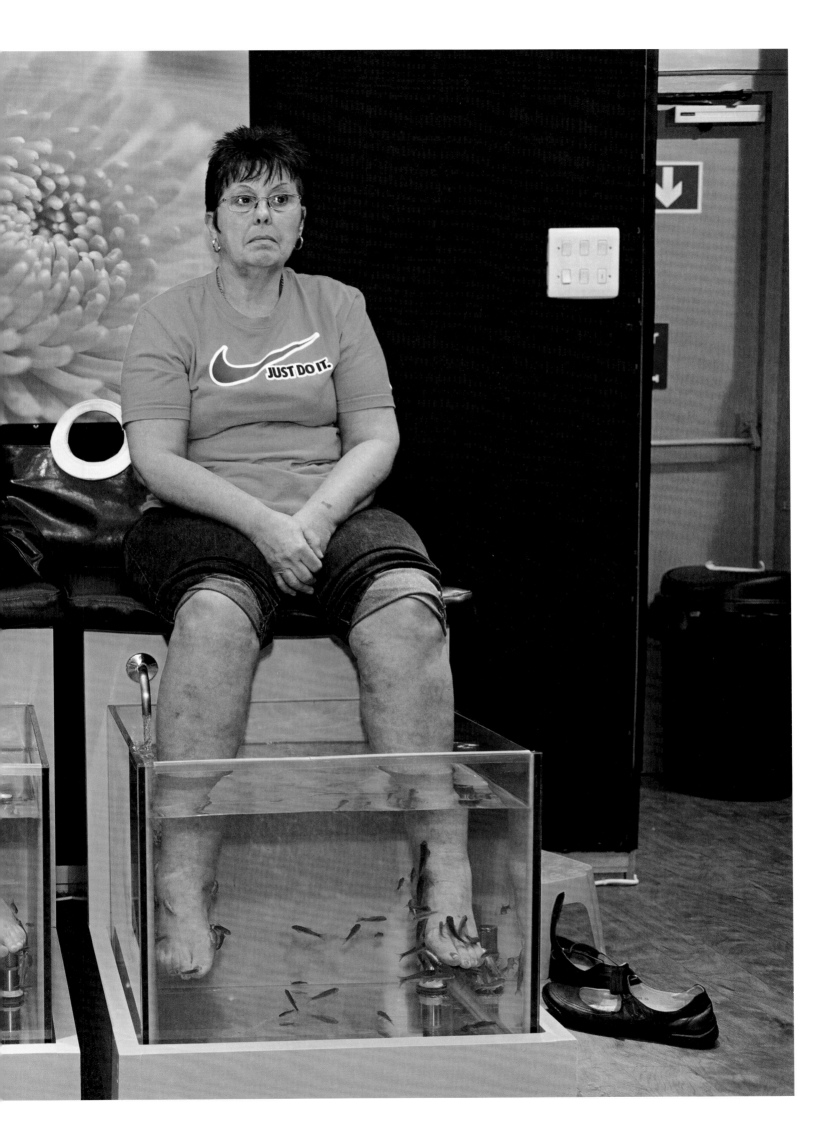

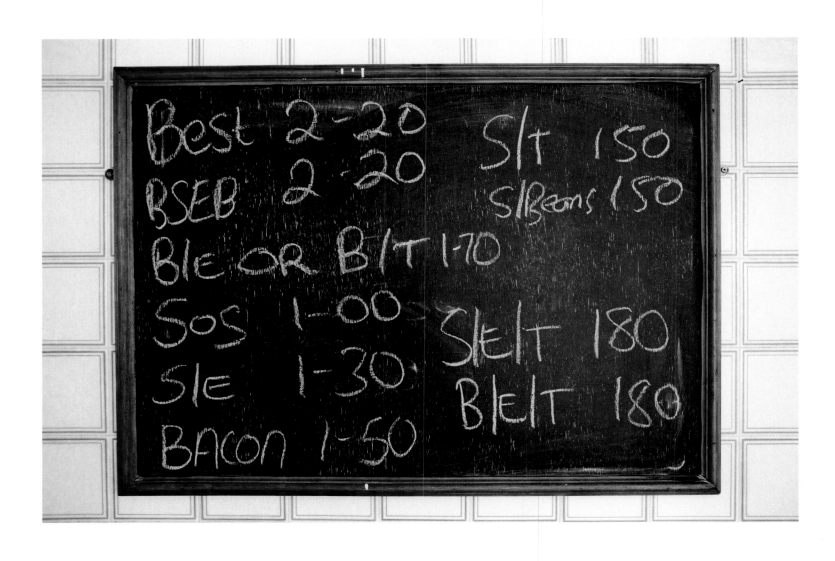

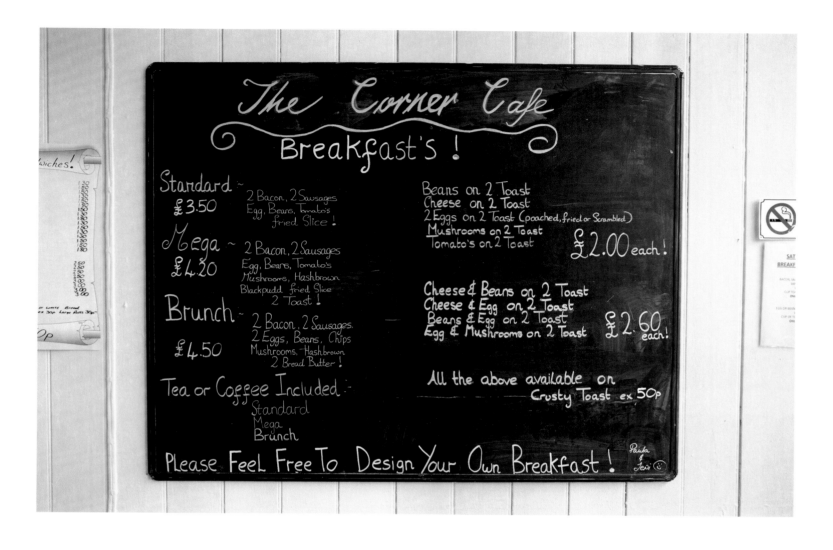

The Corner Cafe
Breakfast's !

Standard ~
£3.50
2 Bacon, 2 Sausages
Egg, Beans, Tomato's
Fried Slice !

Mega ~
£4.20
2 Bacon, 2 Sausages
Egg, Beans, Tomato's
Mushrooms, Hashbrown
Blackpudd Fried Slice
2 Toast !

Brunch ~
£4.50
2 Bacon, 2 Sausages.
2 Eggs, Beans, Chips
Mushrooms, Hashbrown
2 Bread Butter !

Tea or Coffee Included :-
Standard
Mega
Brunch

Beans on 2 Toast
Cheese on 2 Toast
2 Eggs on 2 Toast (poached, fried or Scrambled)
Mushrooms on 2 Toast
Tomato's on 2 Toast
£2.00 each!

Cheese & Beans on 2 Toast
Cheese & Egg on 2 Toast
Beans & Egg on 2 Toast
Egg & Mushrooms on 2 Toast
£2.60 each!

All the above available on
Crusty Toast ex 50p

Please Feel Free To Design Your Own Breakfast !

Paula & Teri

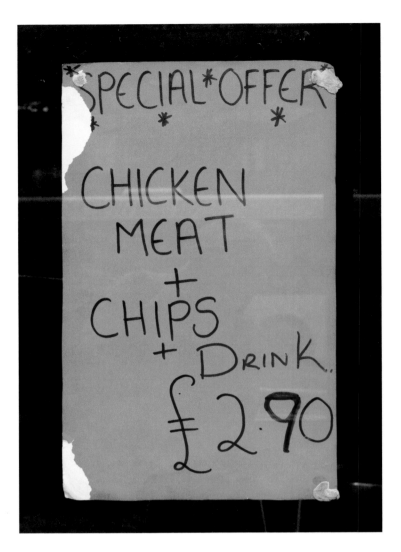

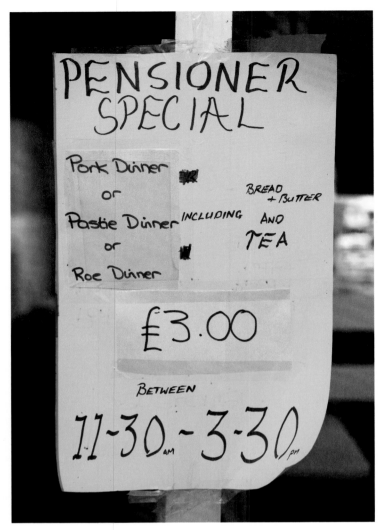

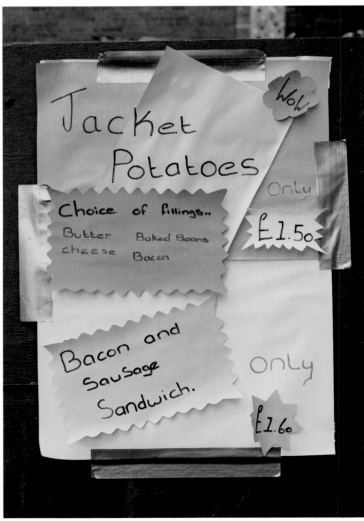

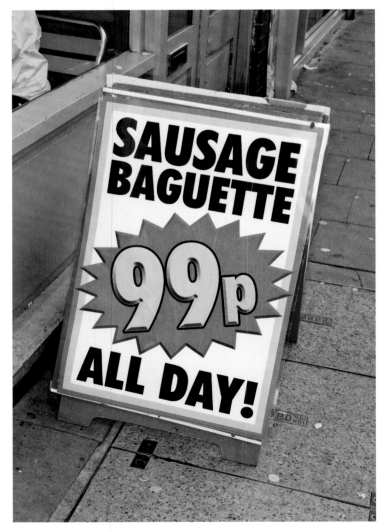

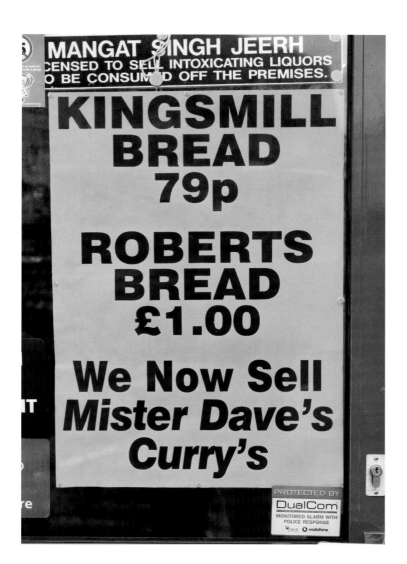

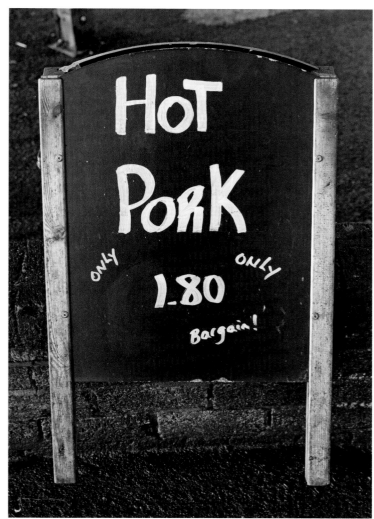

Previous page: Food Bank, Wolverhampton
Right: Harbhajan Singh, Willenhall Market

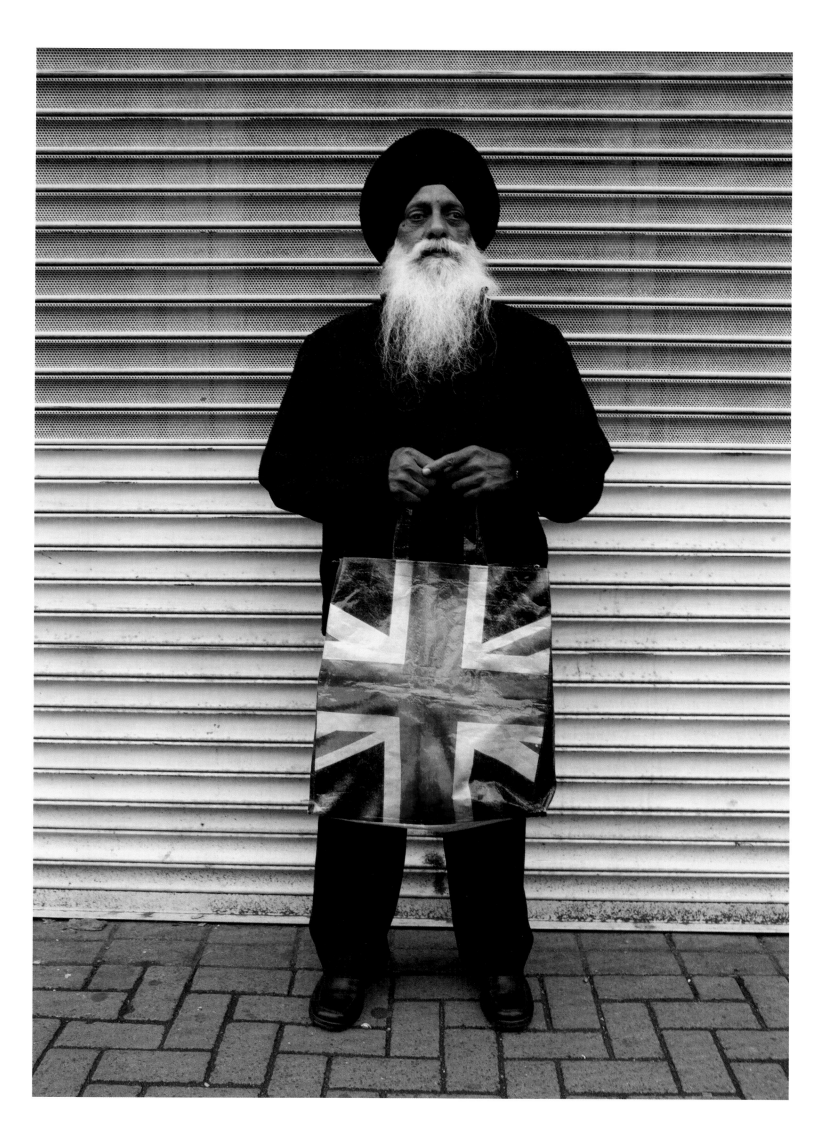

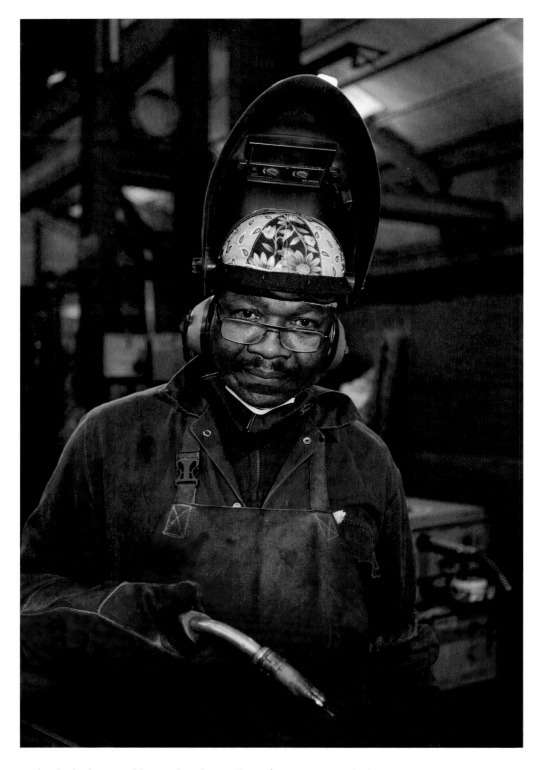

Frederick Abraham, Welder, employed at Steelways for 38 years, Wolverhampton

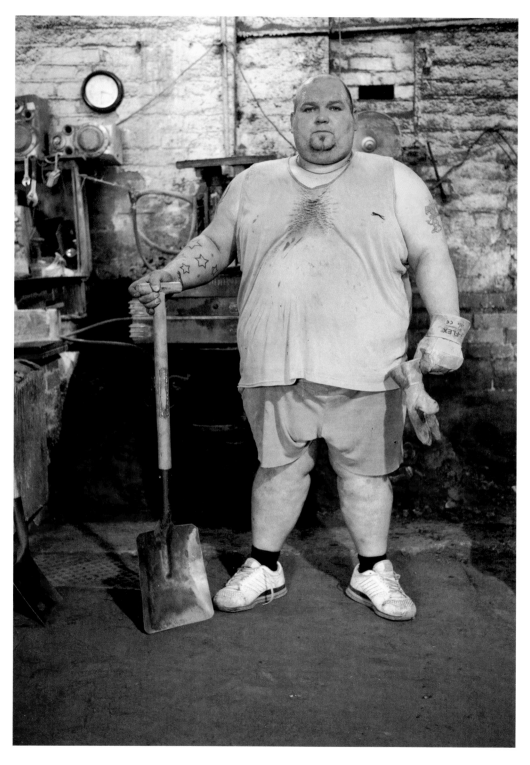

Lee Cox, Moulder, Kirkpatrick's Ironworks, Walsall

Goodyear Dunlop, tyre factory, Wolverhampton

Goodyear Dunlop, tyre factory, Wolverhampton
Following page: Father & son, Brian & Ross Cartwright, Griffin Woodhouse Ltd, chain makers, Cradley Heath

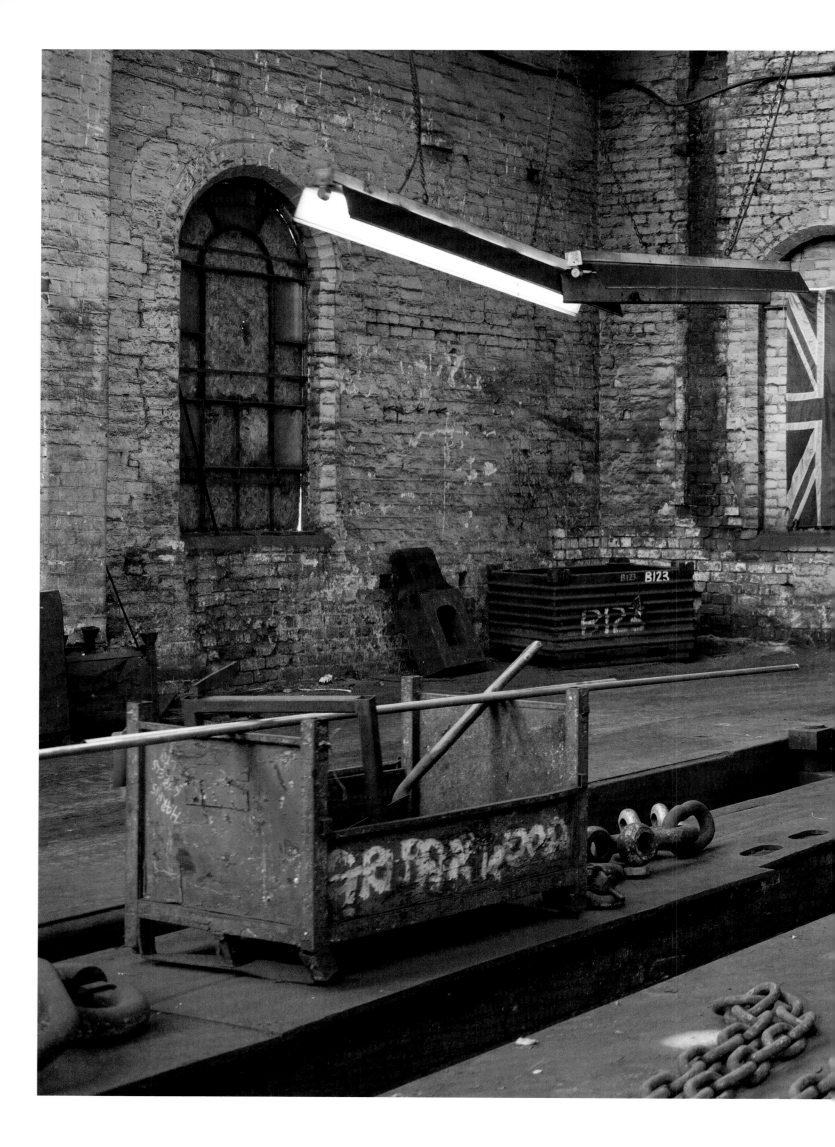

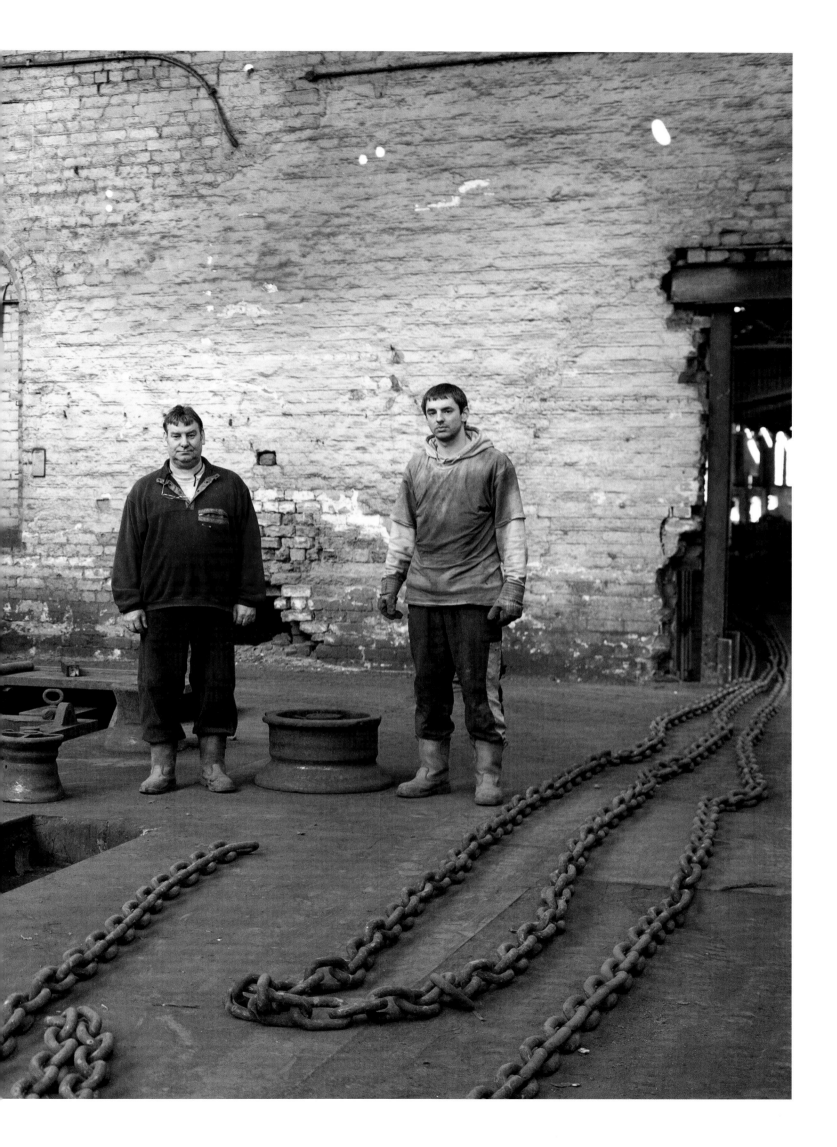

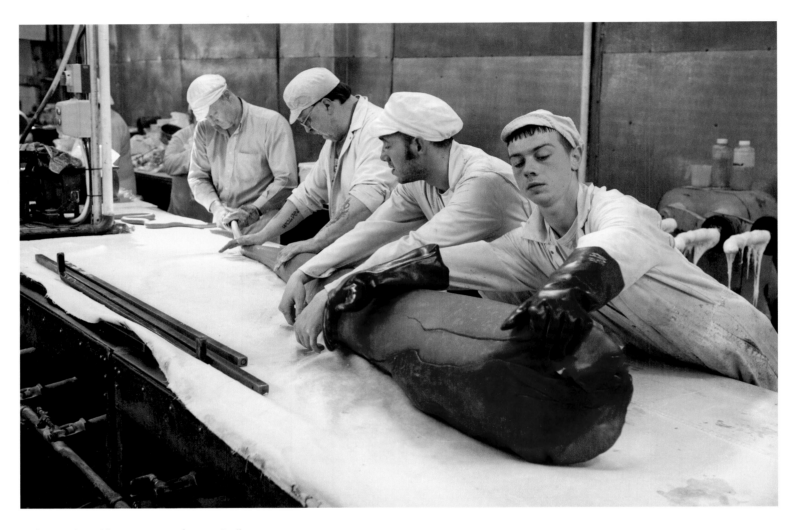

Making rock, Teddy Gray's sweet factory, Dudley

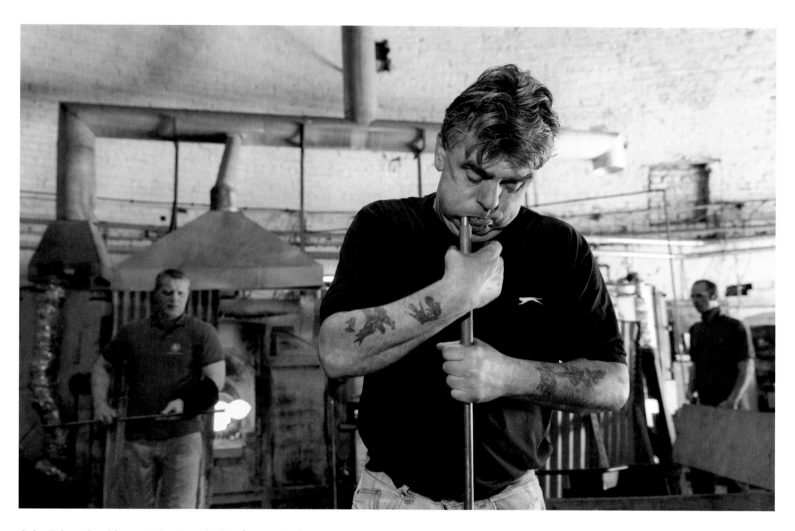

Colin Oden, glass blower, Tudor Crystal, glass factory, Dudley
Following page: Keith Carrier & Son, lock and key specialists, Walsall

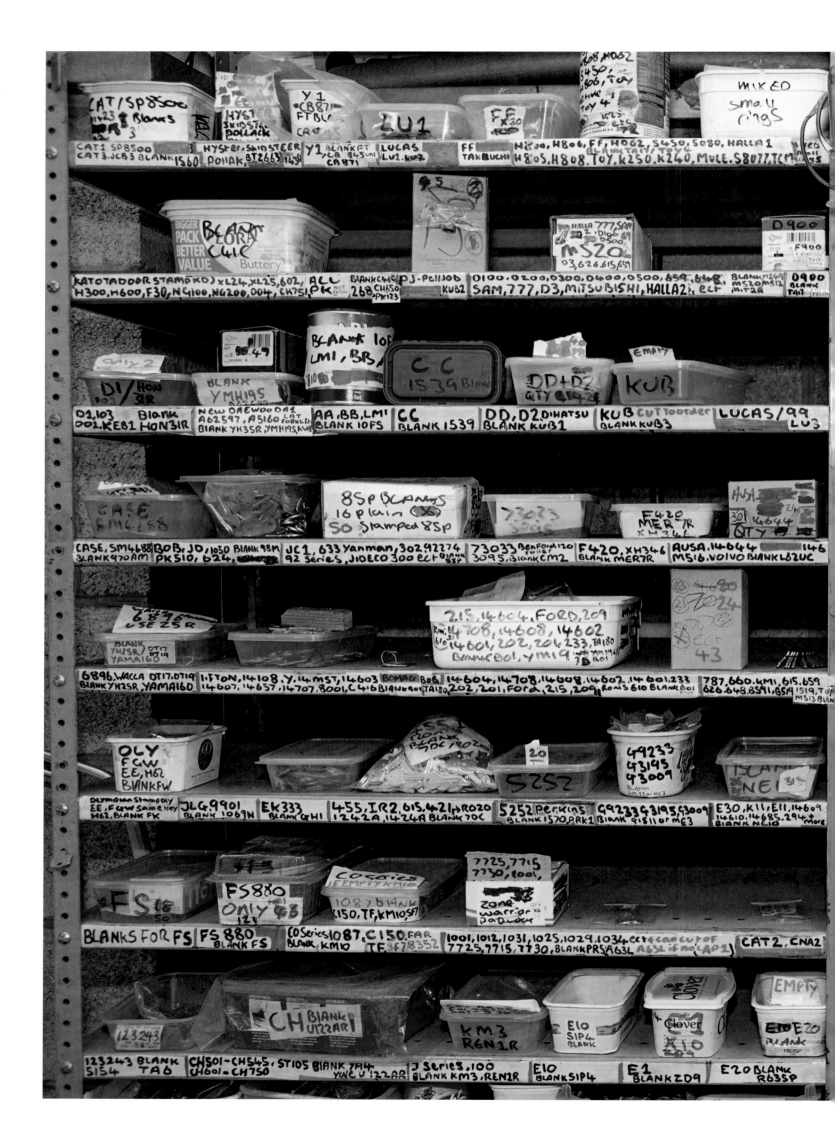

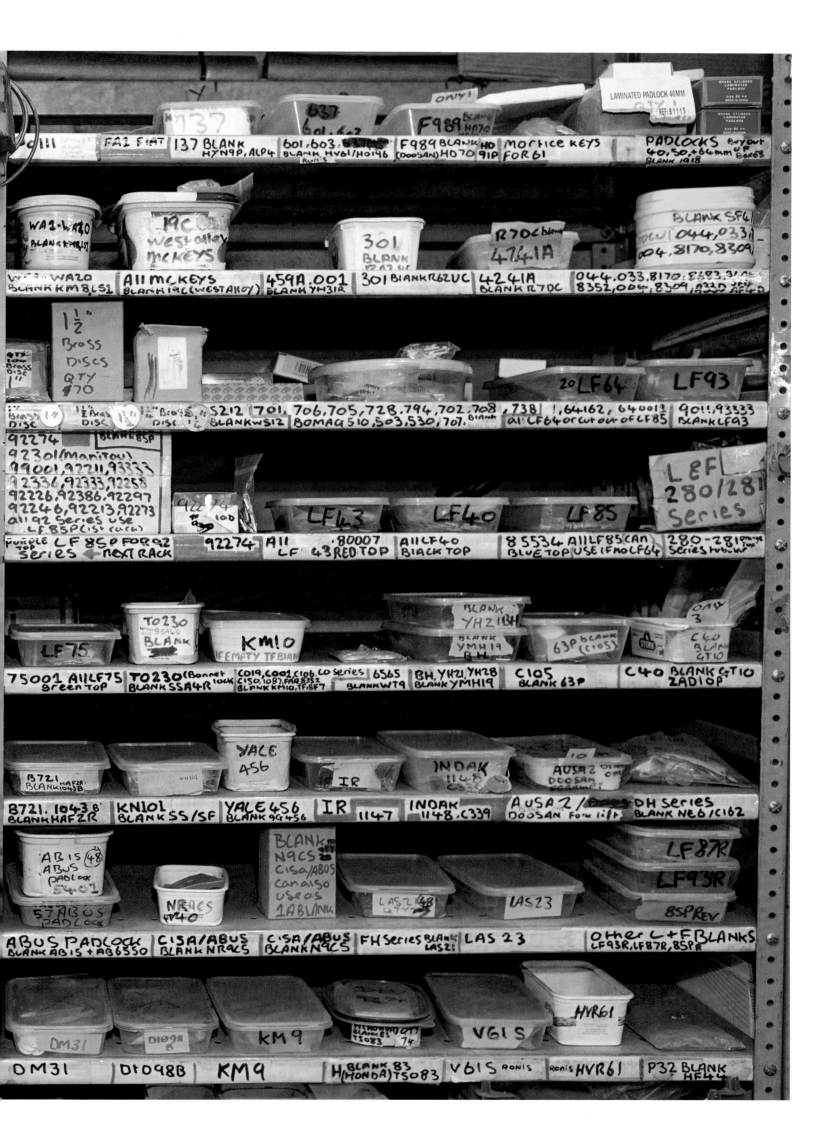

Steph Wilcox, Manager, JMP Wilcox & Co Ltd, textile re-claimers, Bilston

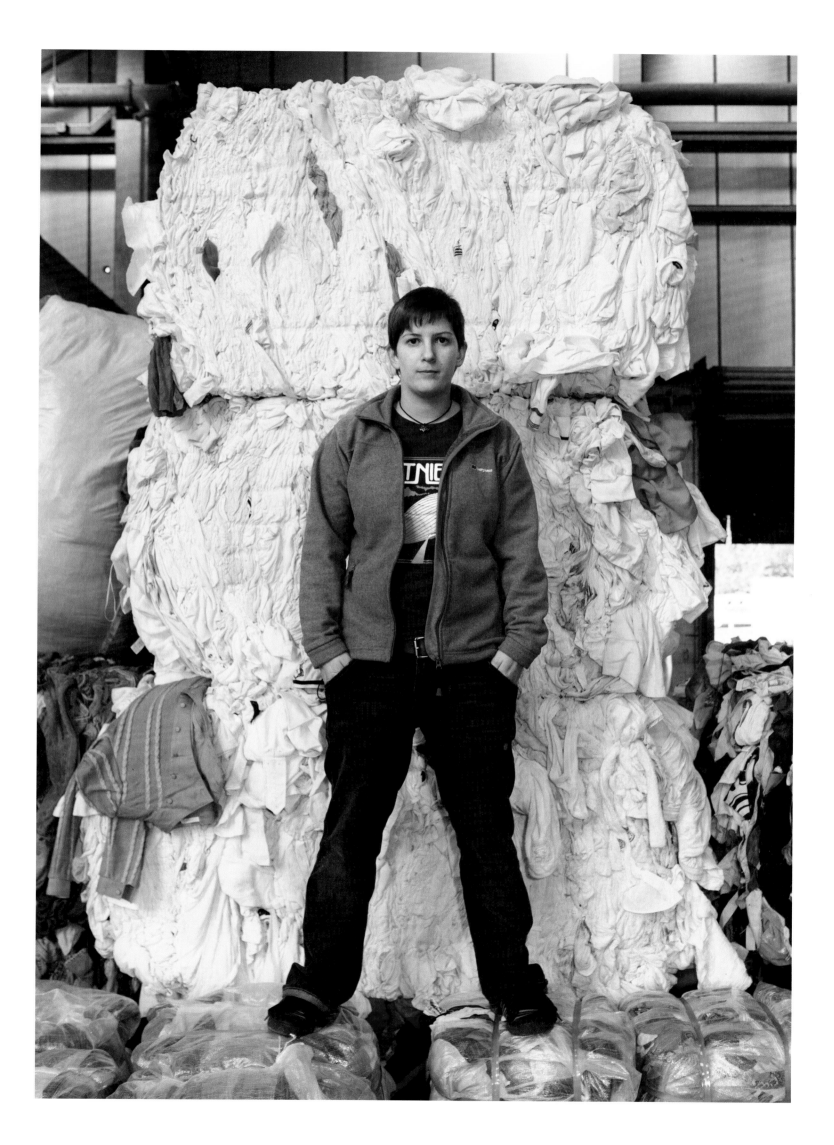

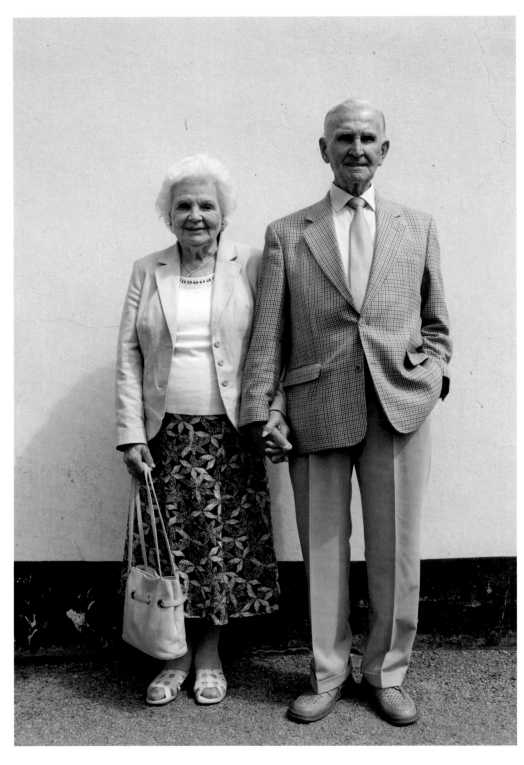

Mr & Mrs Jons, married for 68 years (in 2011), Walsall

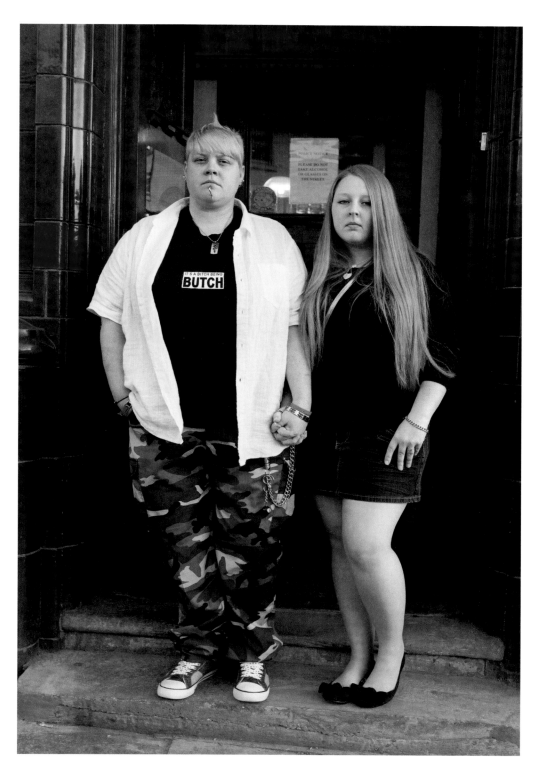

Mandy White (right) and Beccie, Walsall

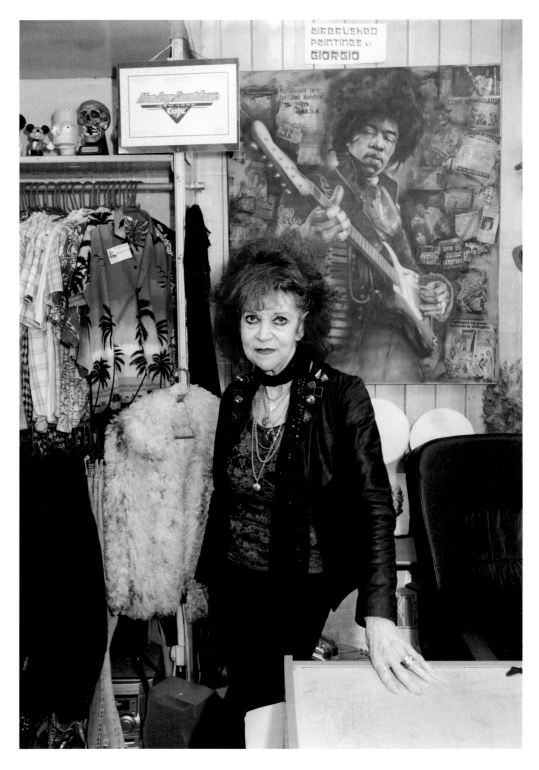

Trisha Uccellini, Trisha's vintage shop, Wolverhampton

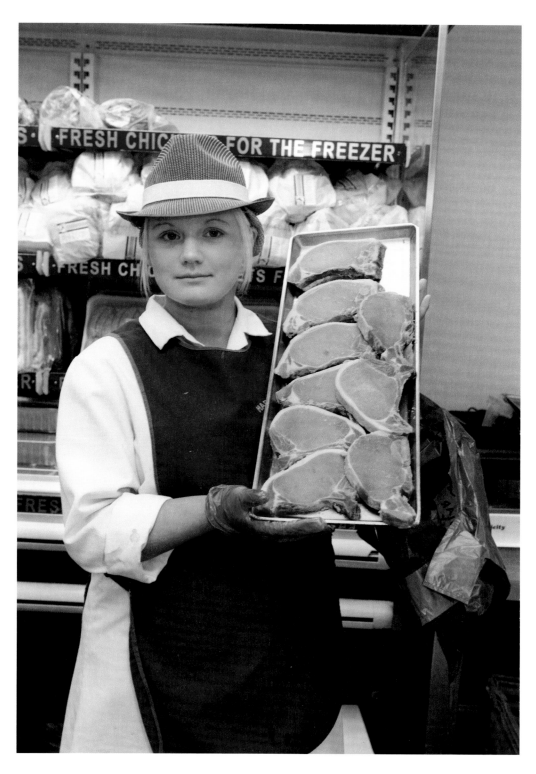

Hannah Cash, Harper Meats, Bilston Market

Champion's Church, Netherton

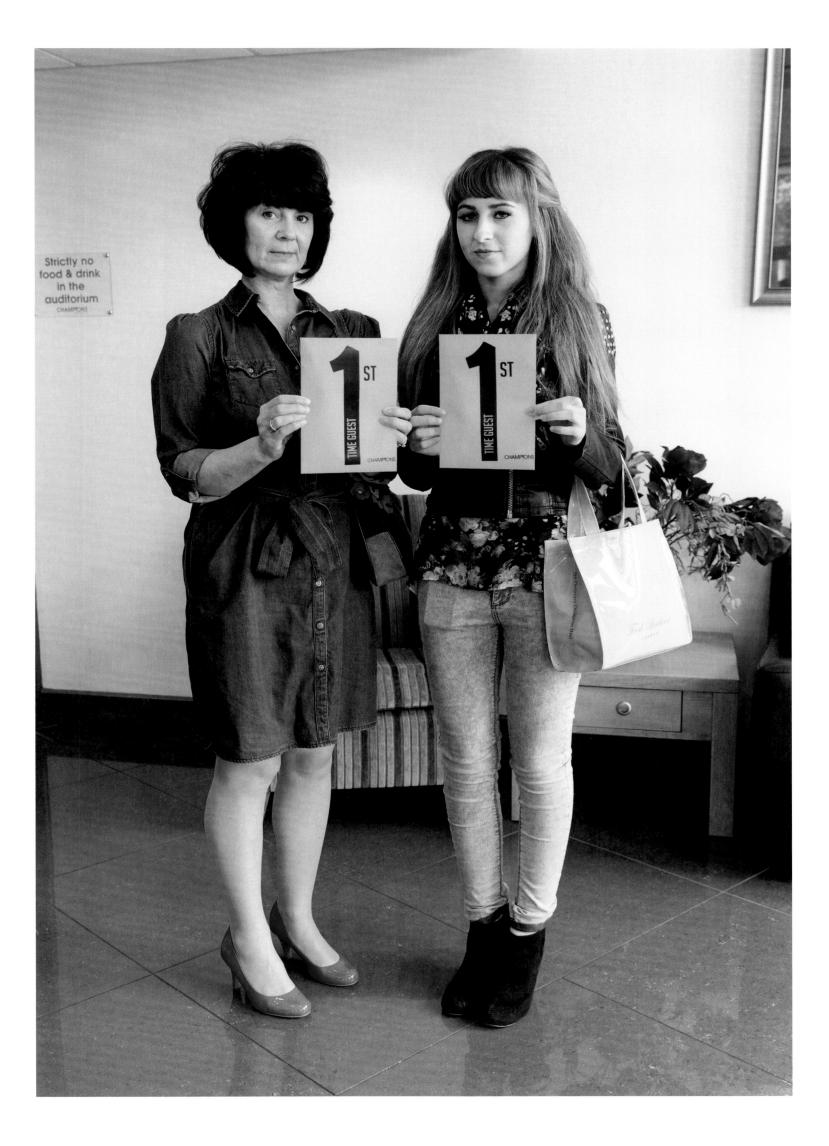

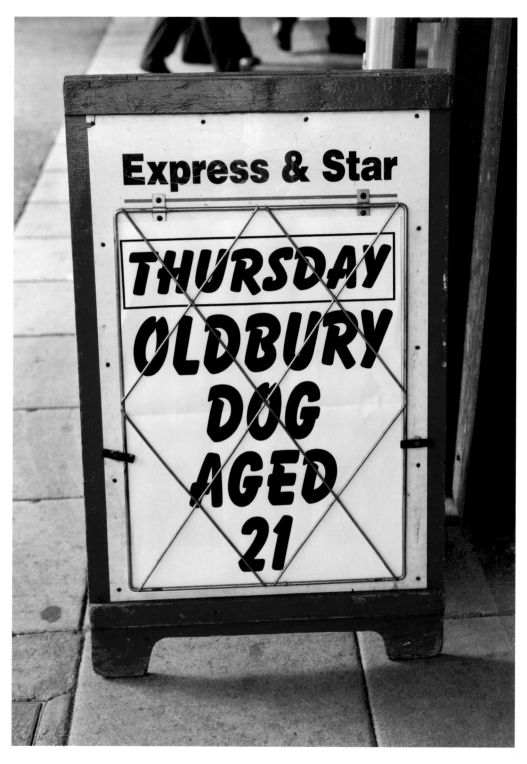

West Bromwich

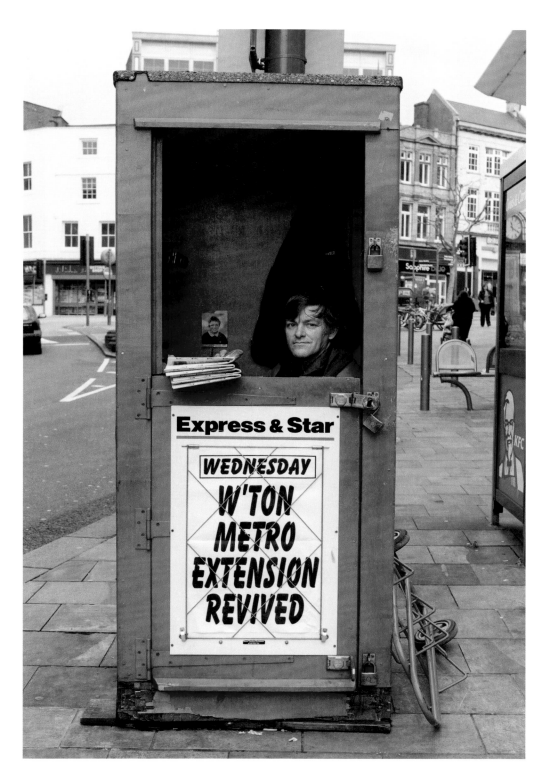

Phil Howells, Wolverhampton

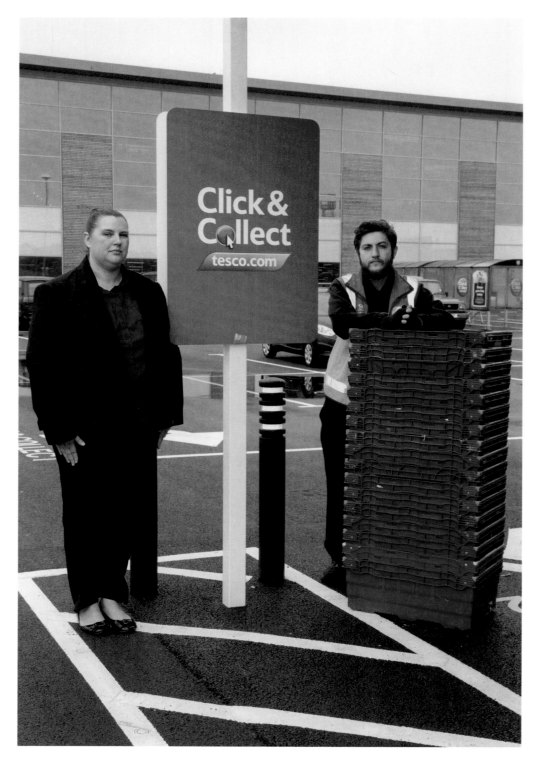

Sharon Rencord & Adam Withington, Tesco, Dudley

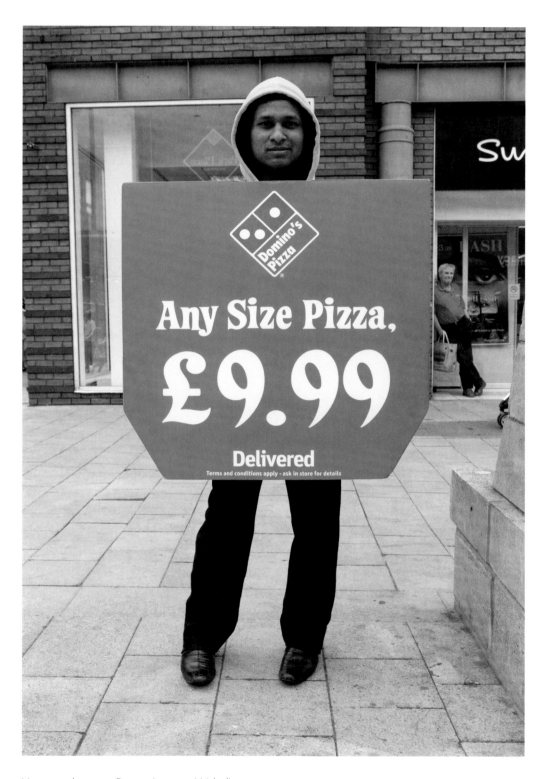

Hussain advertising Domino's pizza, Walsall

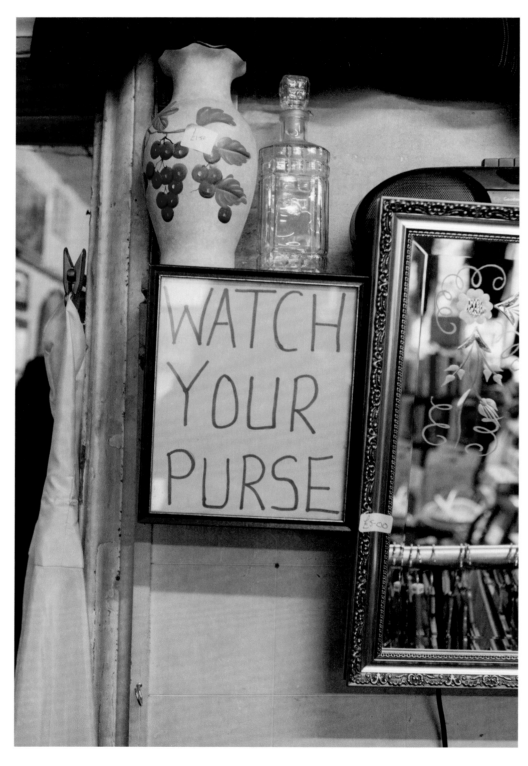

Animal Concern, charity shop, Willenhall

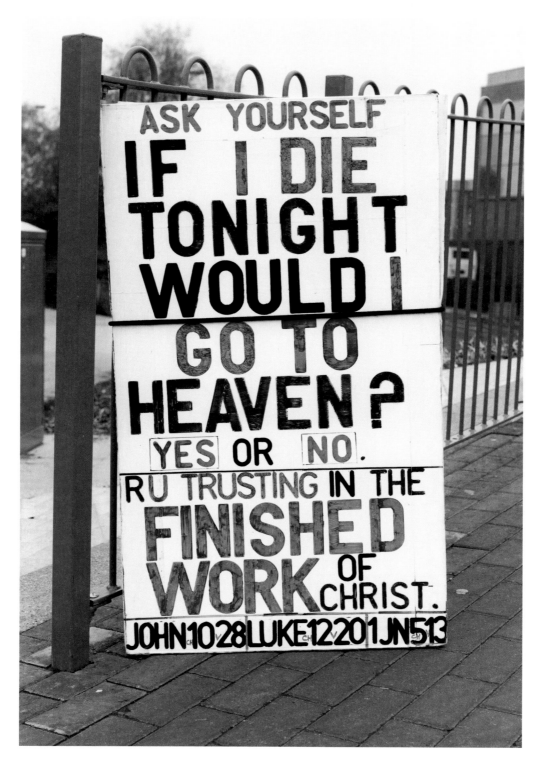

Wolverhampton

Emily Scarrott & Mark Smith, Wolverhampton

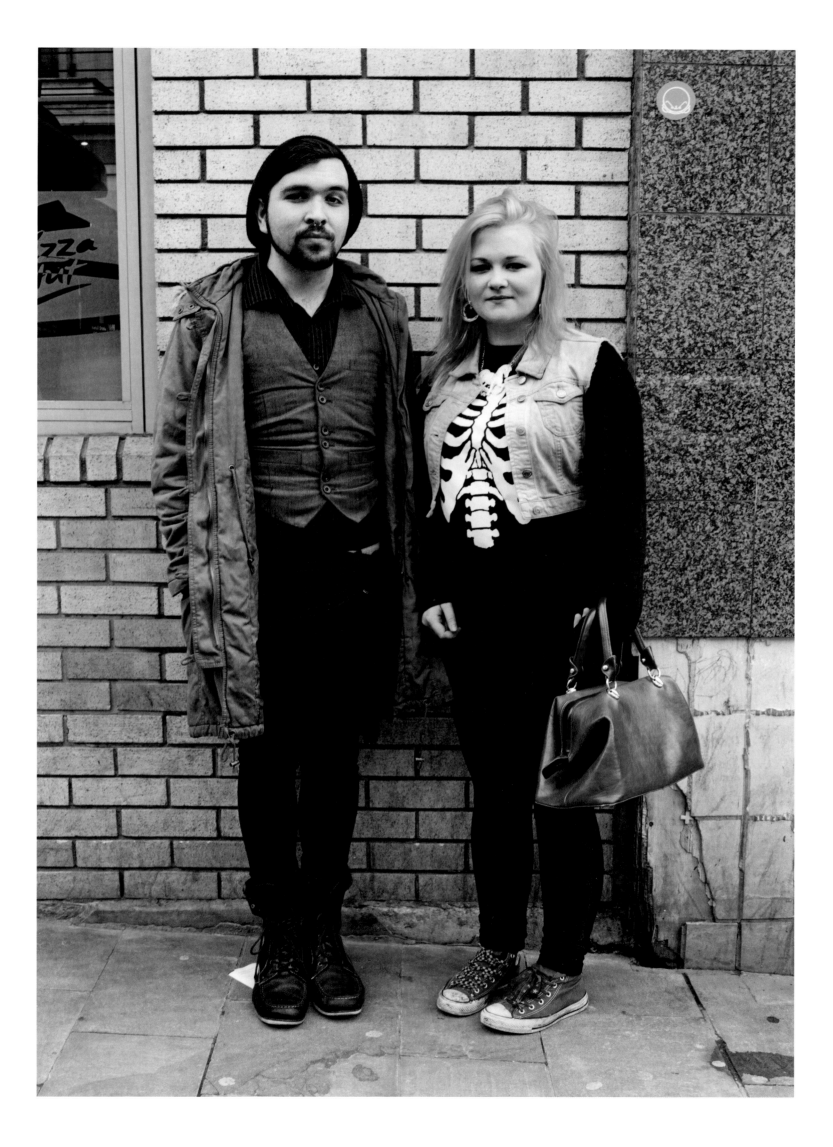

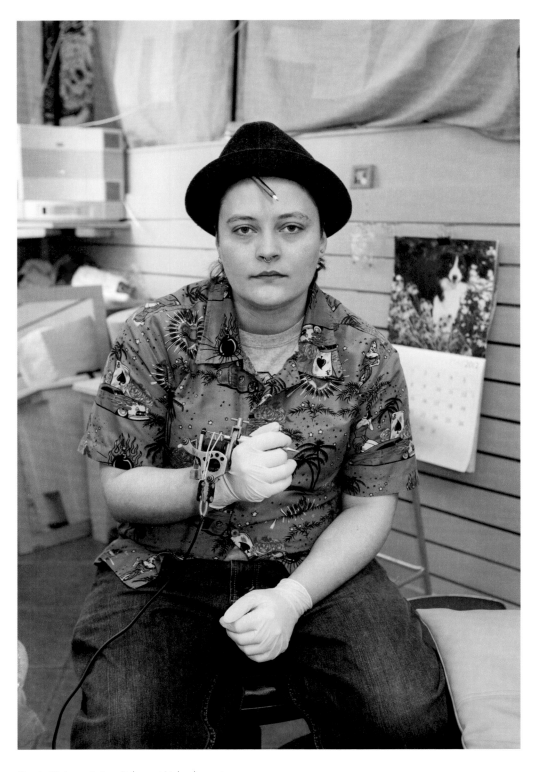

Stacie Coisne, Tattoo Palace, Wolverhampton

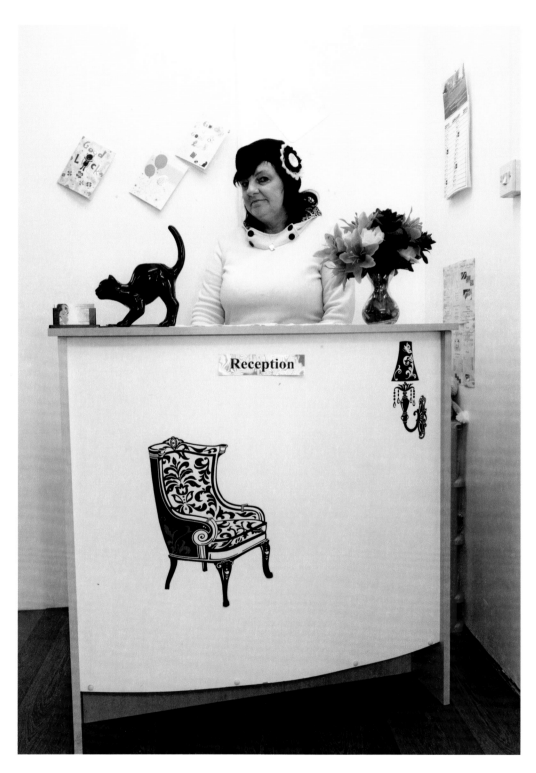

Sharon Izon, Just For You beauty salon, Netherton
Following page: Jimmy and Michelle Owen, ferret boarding & rescue, Wolverhampton

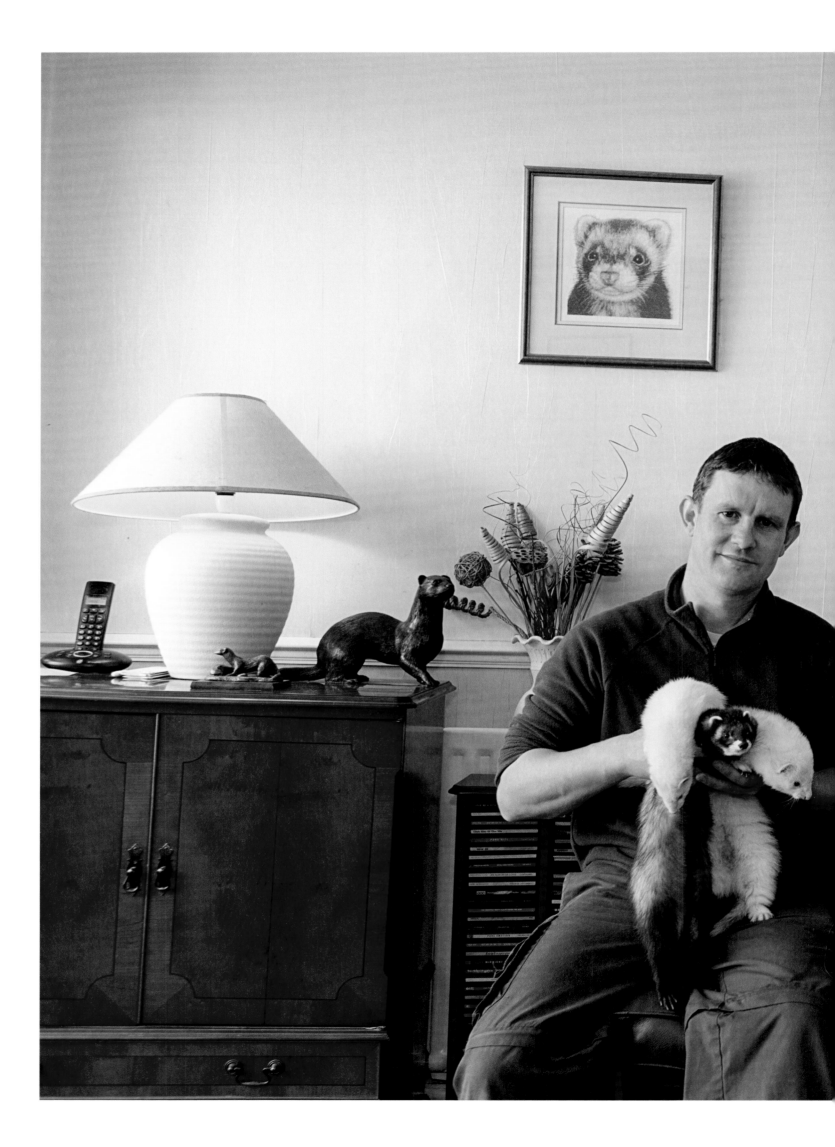

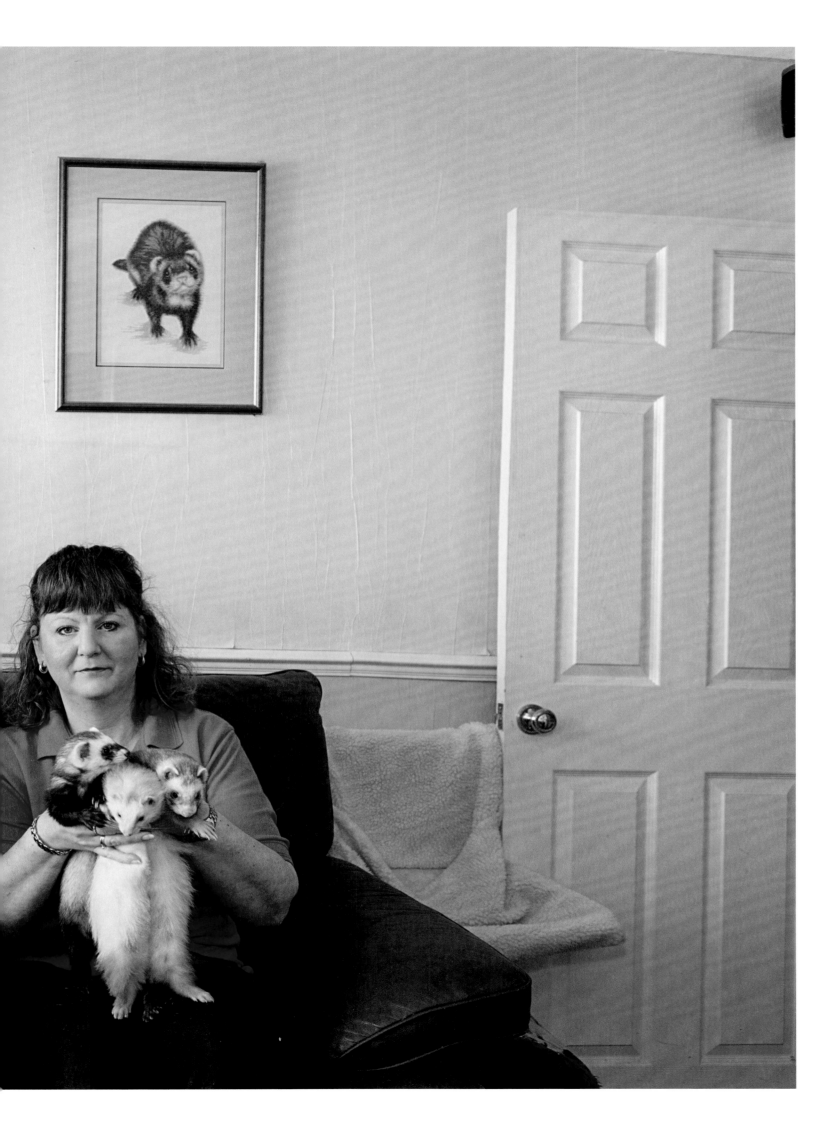

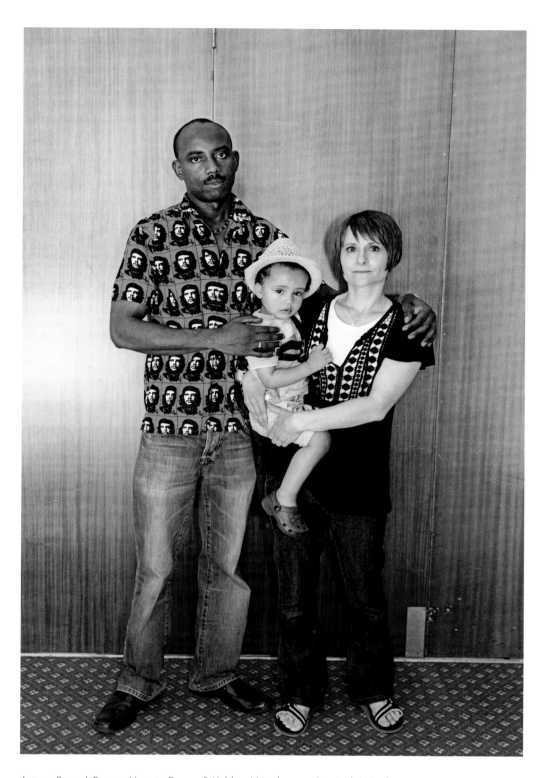

Antony Sanneh-Brown, Victoria Brown & Kebba, Wombourne Carnival, Wombourne
Following page: Raj Kumar, his wife Ruby Kumar (standing) & her sister Pinky Kaur (sitting),
Classic Furniture, Bilston

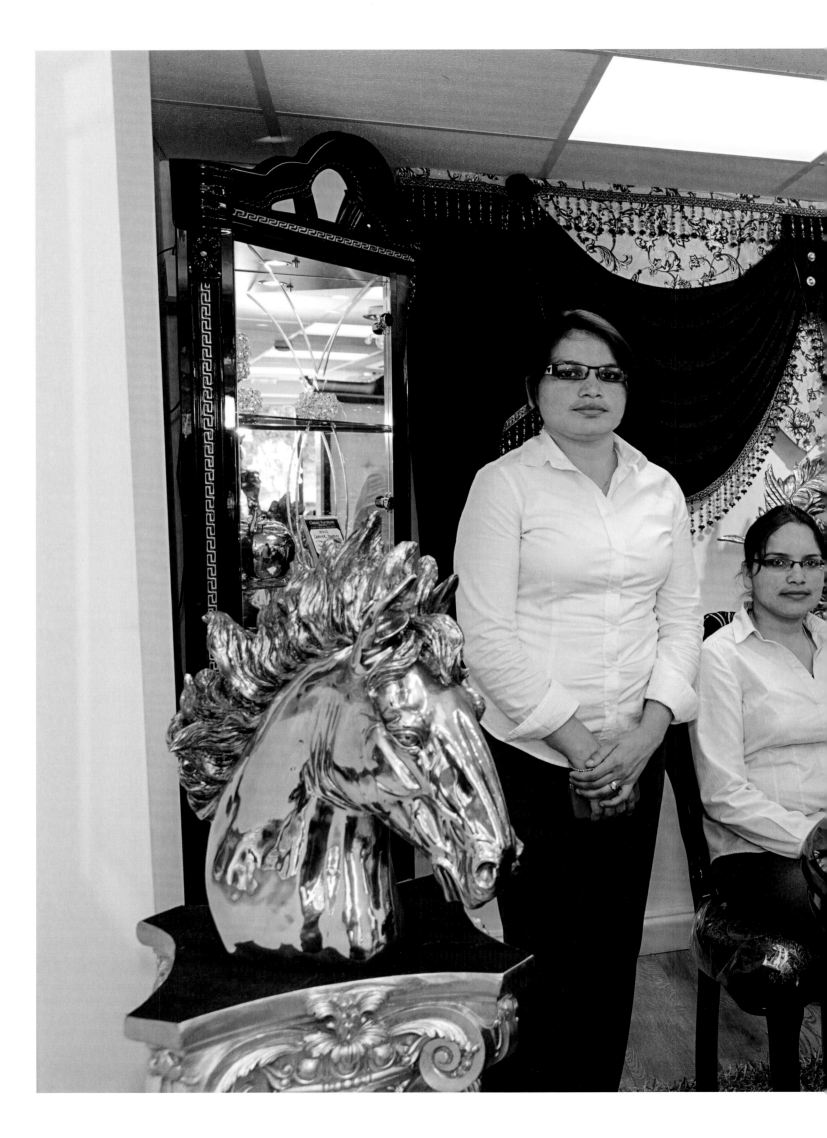

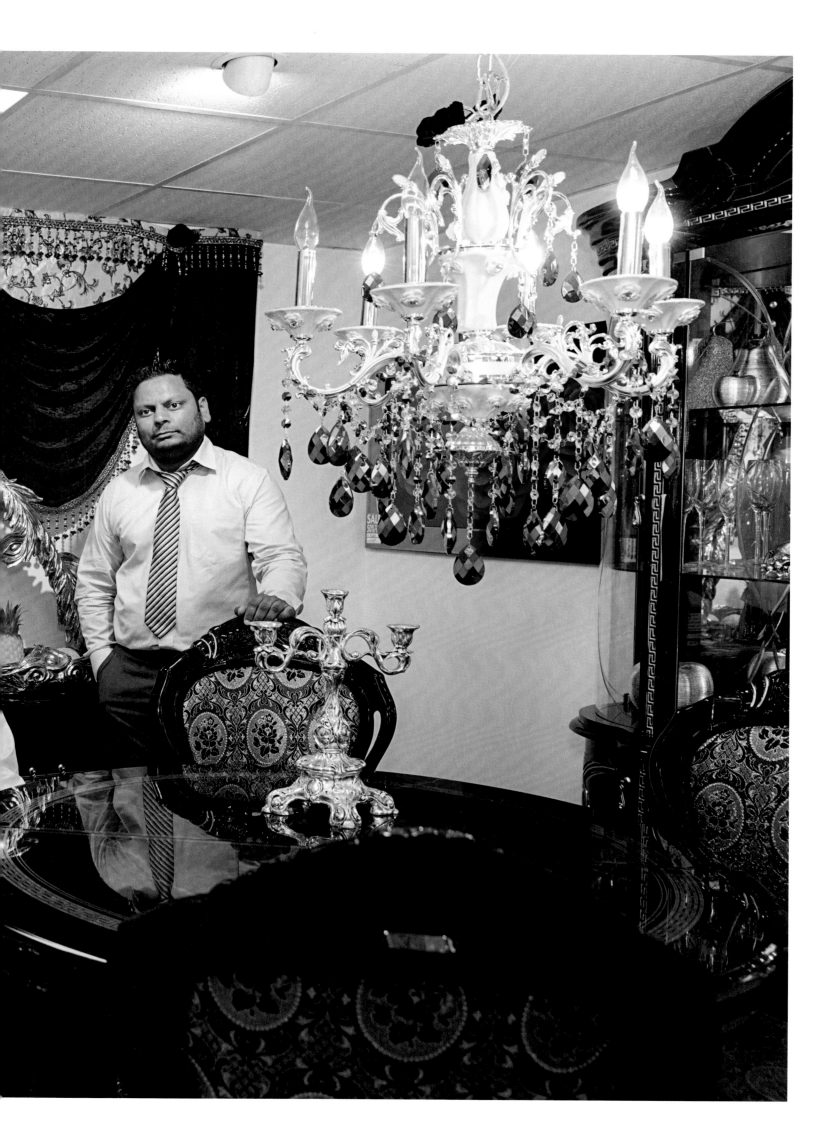

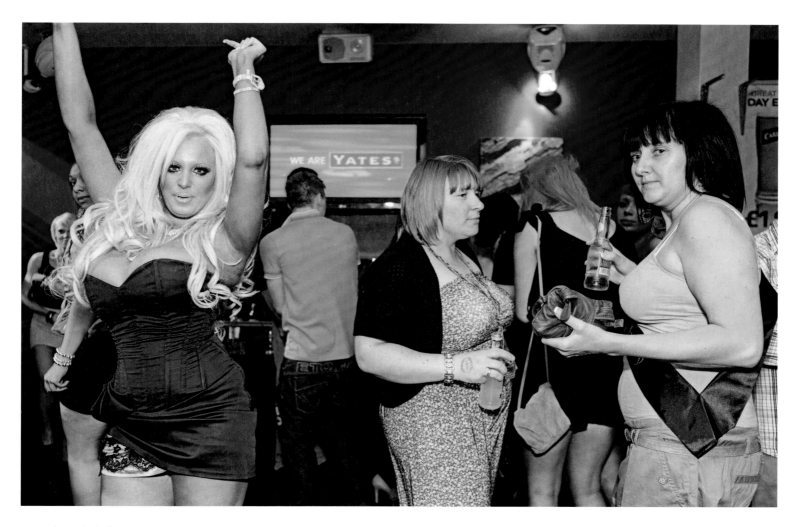

Yates's bar, Walsall

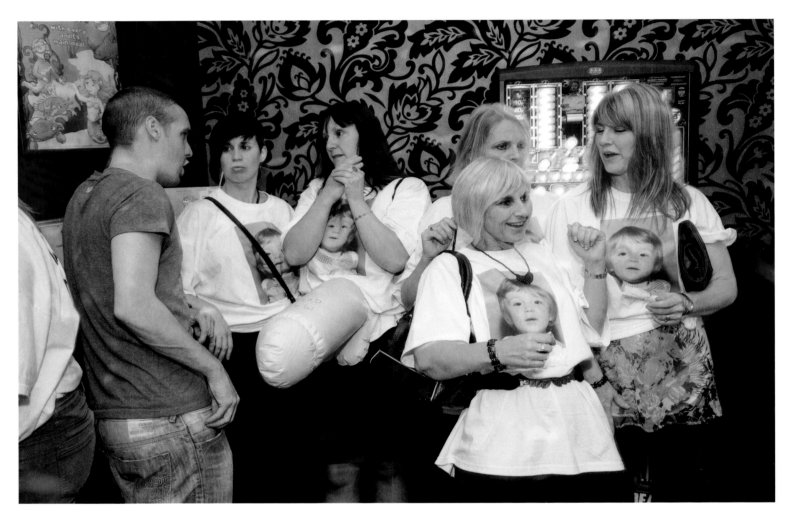

Yates's bar, Walsall

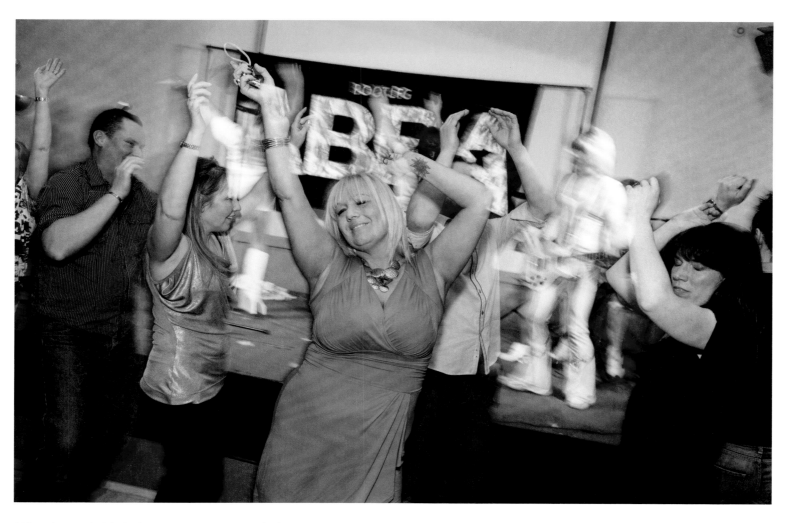

Abba tribute night, Wolverhampton Racecourse, Wolverhampton
Following page: WS1 Nightclub, Walsall

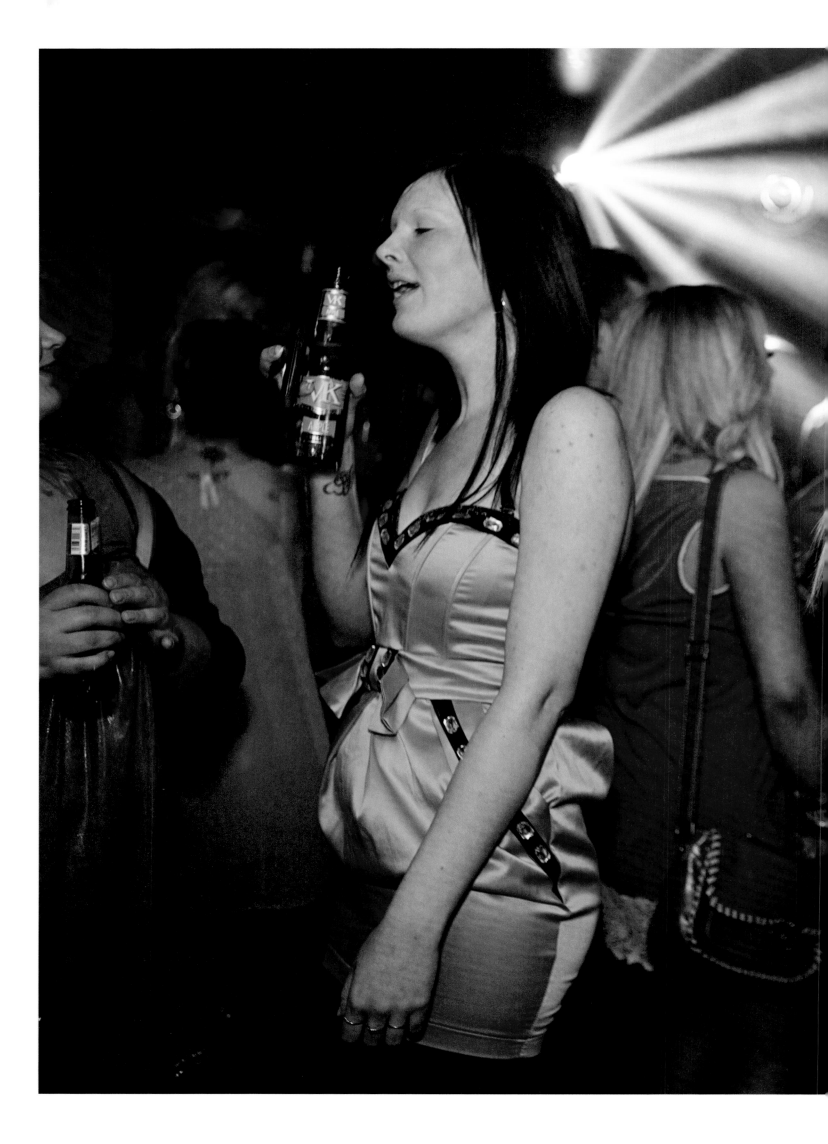

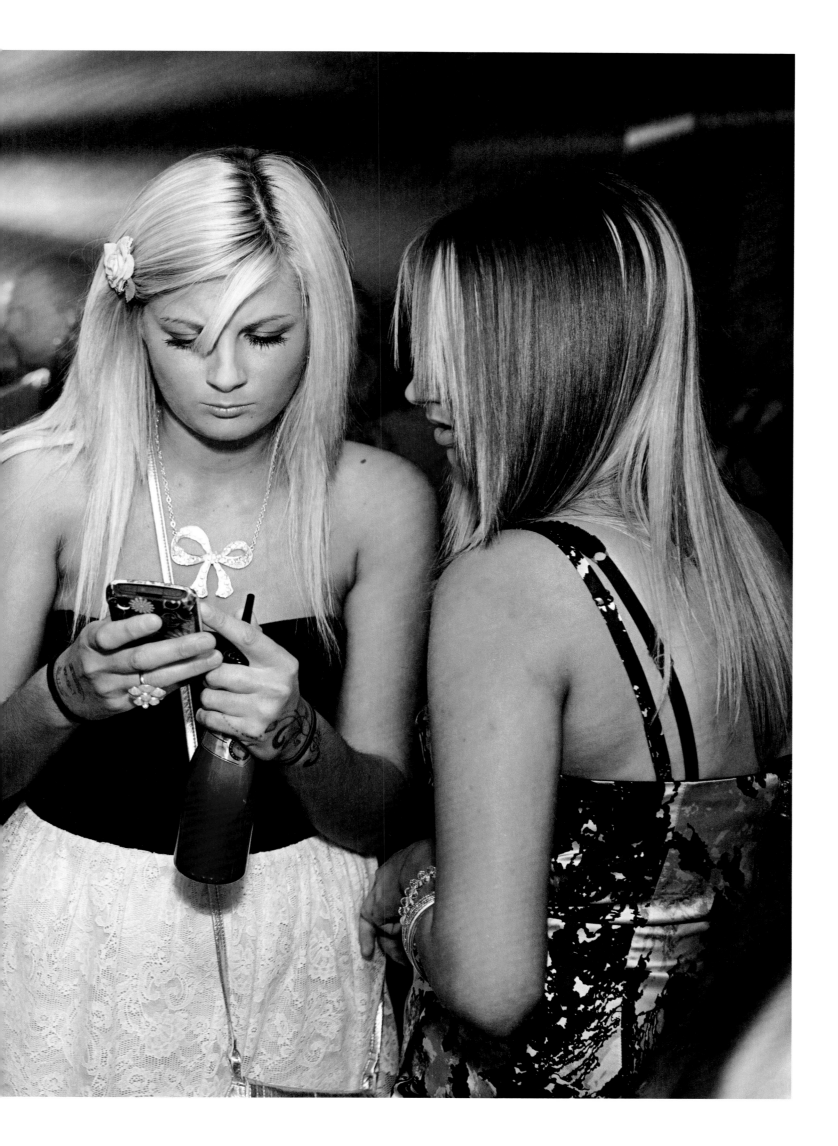

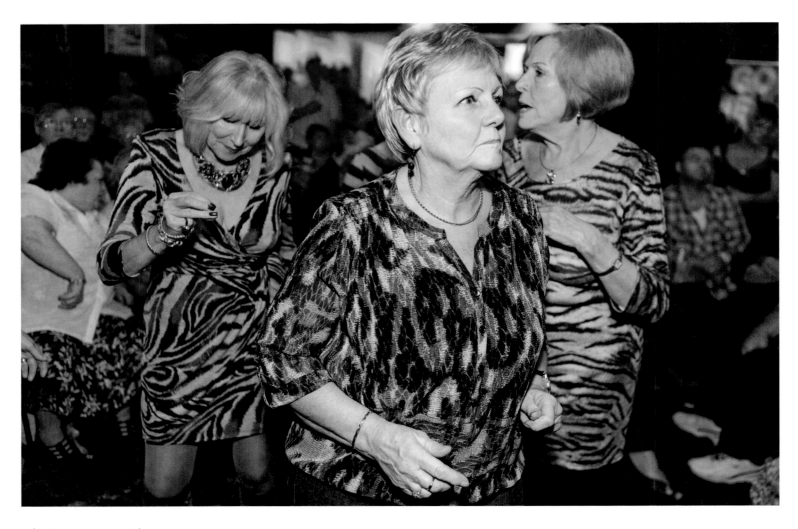

Robin 2, music venue, Bilston

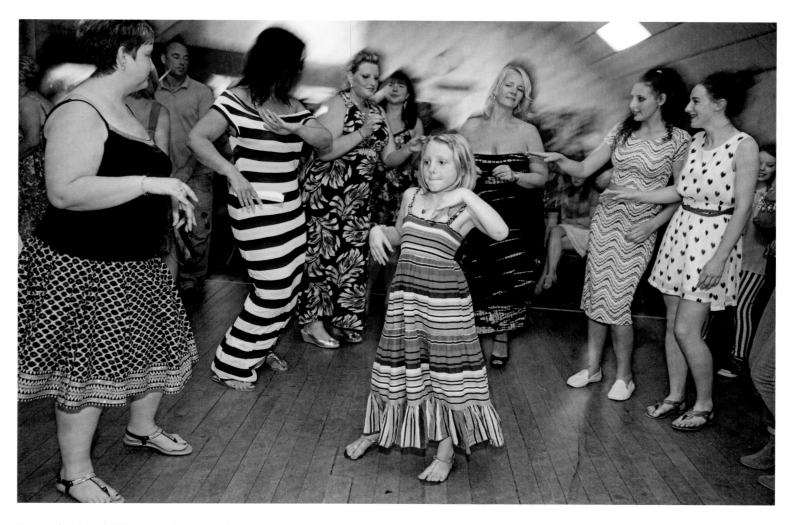

Baggeridge Social Club, Lower Gornal, Dudley
Following page: Northern Soul Night, Goodyears Soul Club, The Pavilion, Wolverhampton

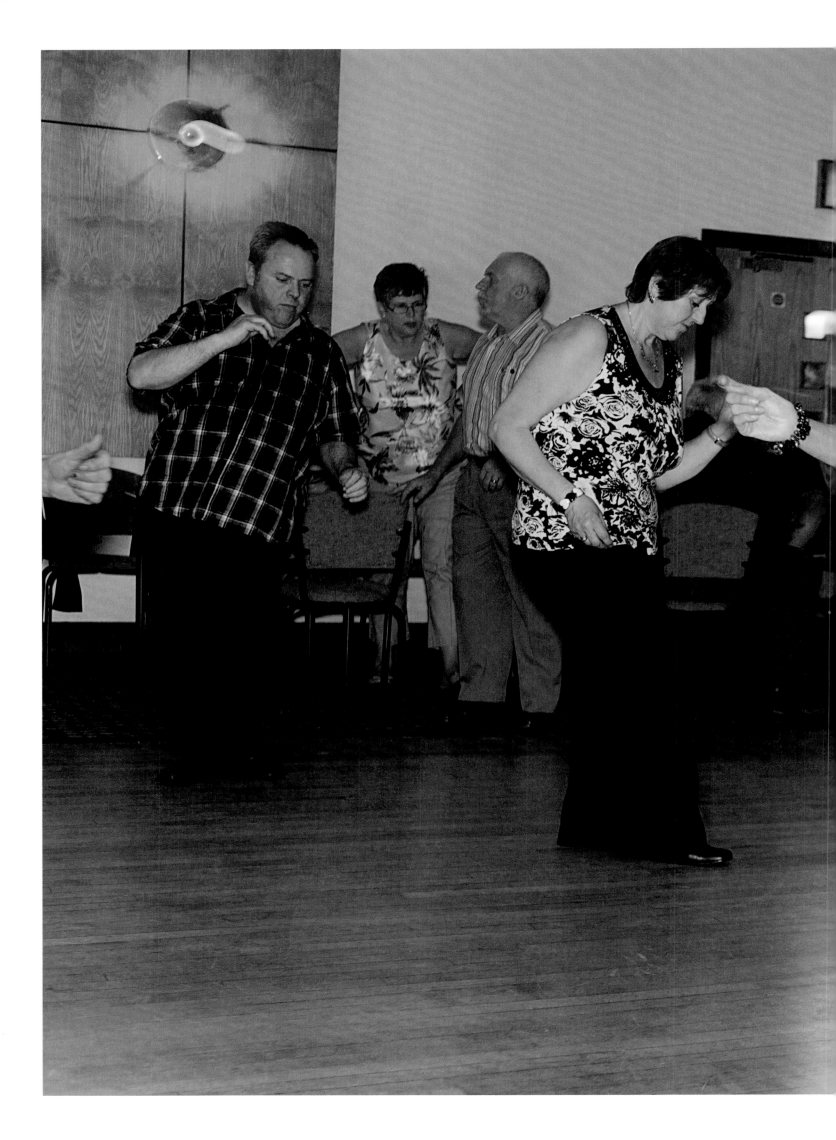

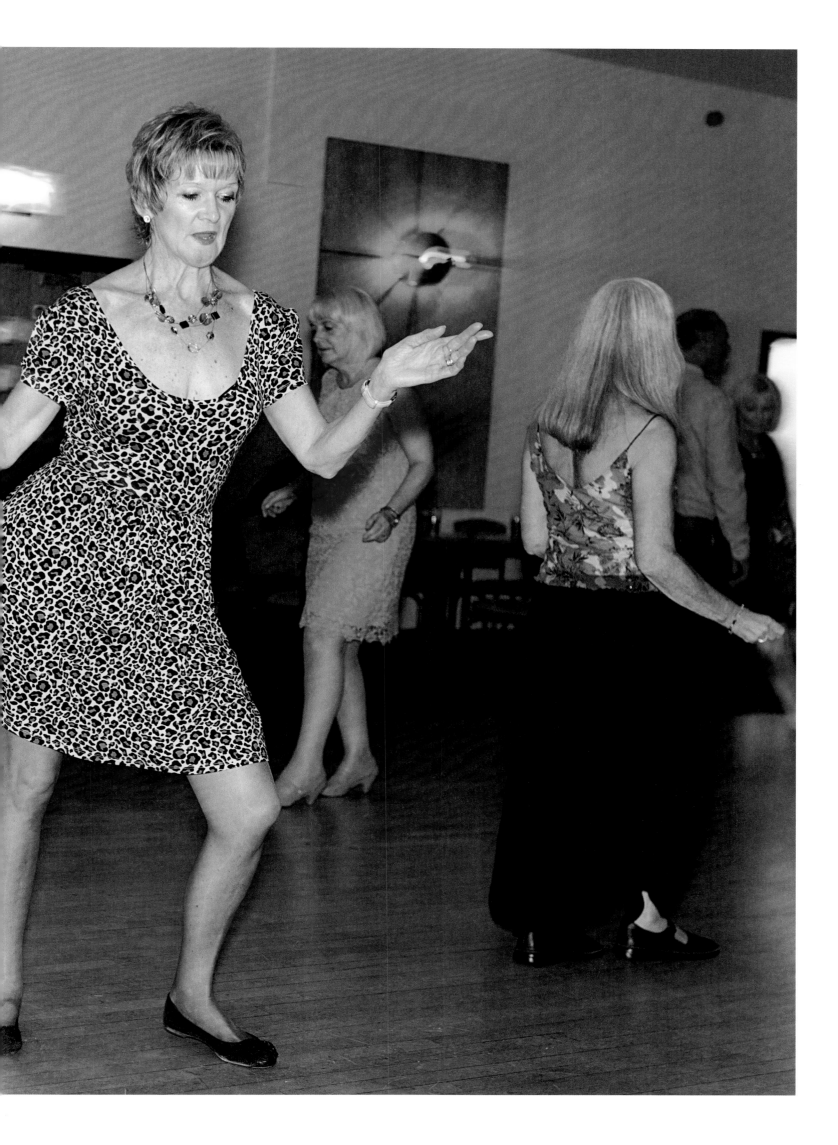

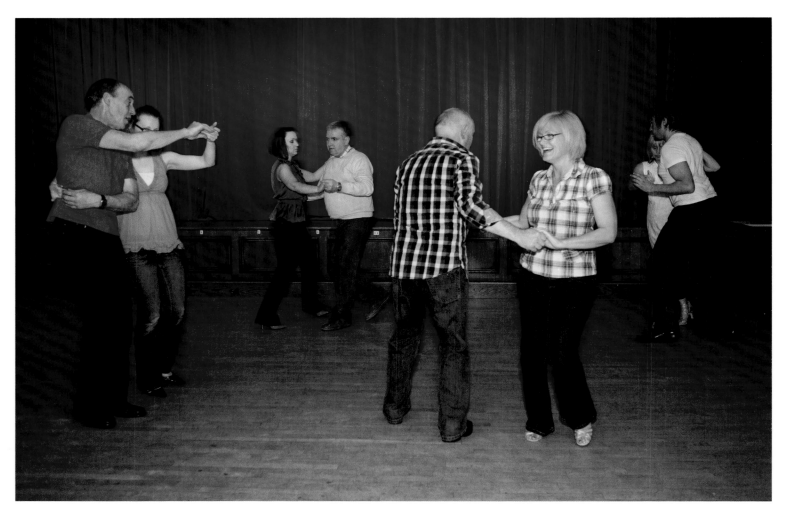

Saddler's Social Club, Walsall

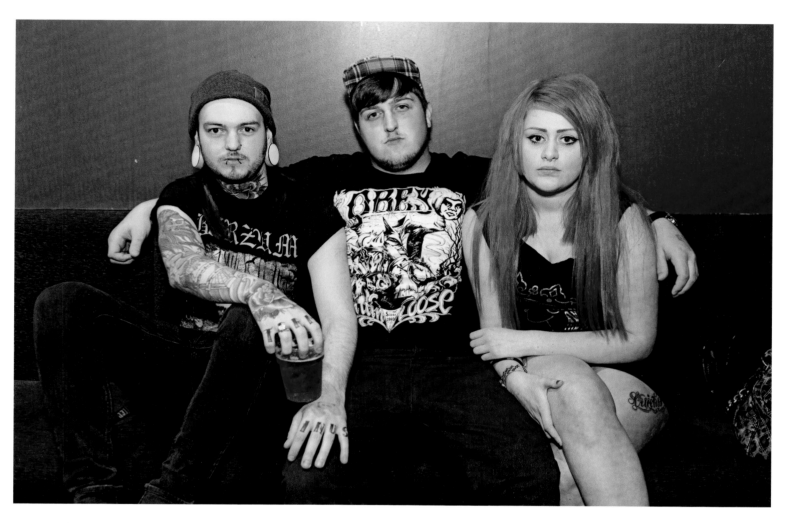

Lewis Weatherly, Jamie Whitshaw & Charlotte Guest, Slade Rooms, Wolverhampton
Following page: Ex-service Men's Club, ballroom dancing, Smethwick

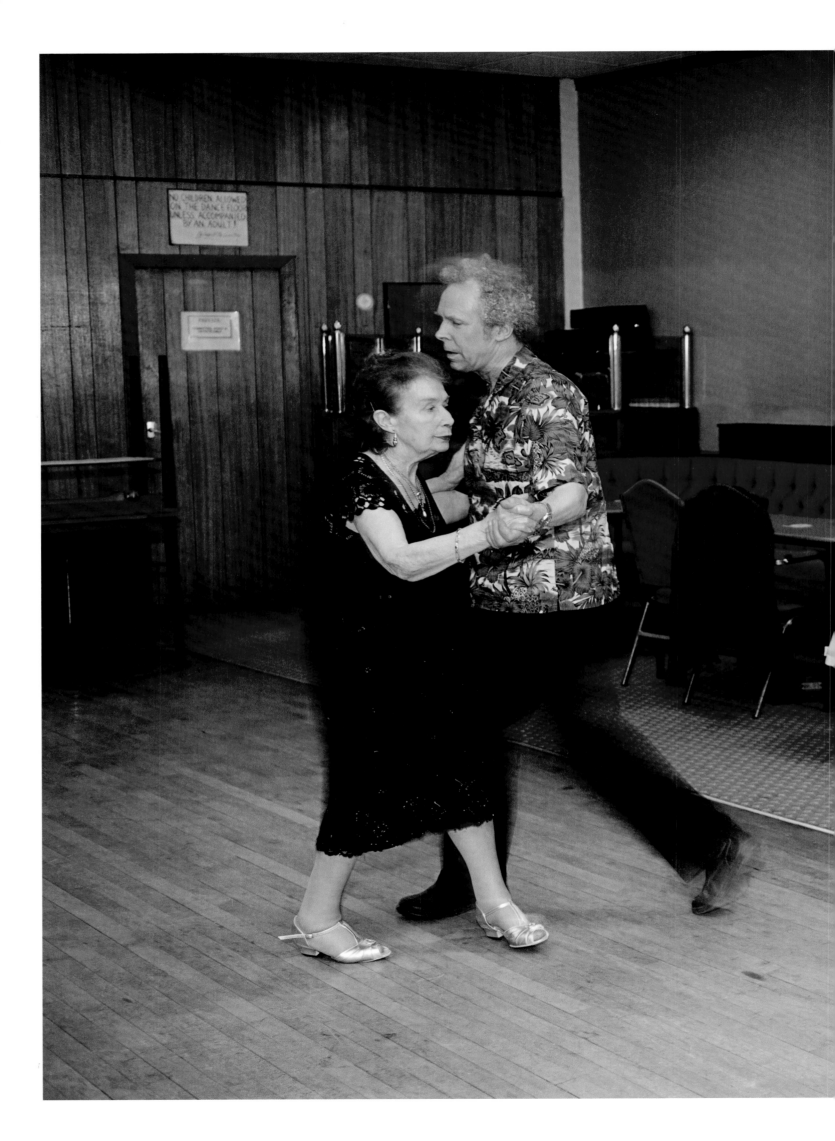

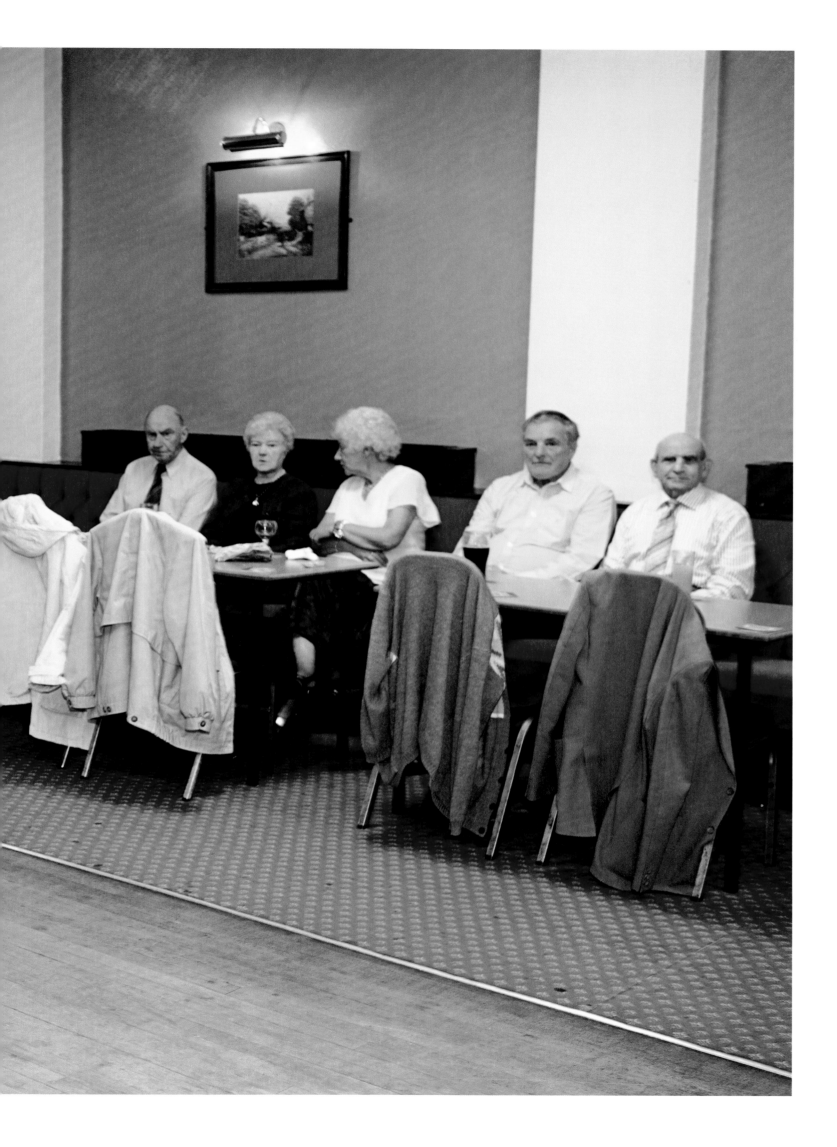

PLEASE NOTE

COACH SEATS WILL BE ALLOCATED IN BOOKING ORDER. SPECIFIC SEATS (ANYWHERE ON COACH) CAN BE BOOKED AT A CHARGE OF £5.00 PER PERSON, IF NOT ALREADY ALLOCATED.

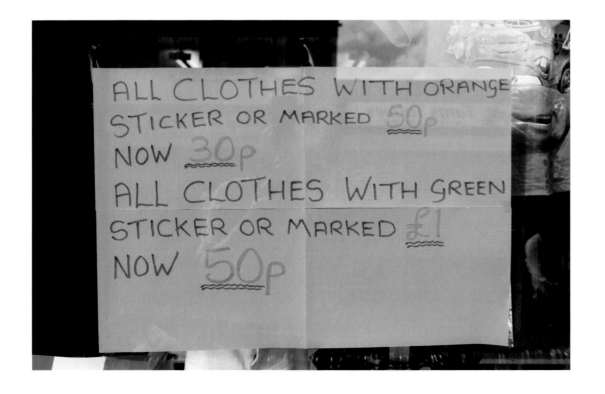

ALL CLOTHES WITH ORANGE STICKER OR MARKED 50p NOW 30p
ALL CLOTHES WITH GREEN STICKER OR MARKED £1 NOW 50p

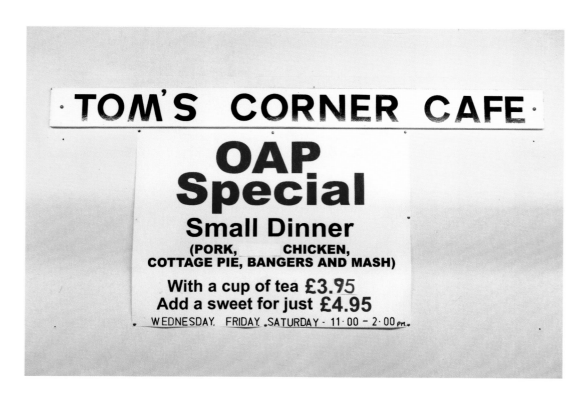

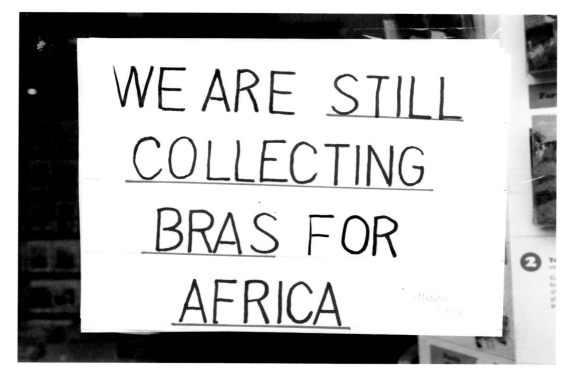

Graham Breeze, Postman, Dudley TA
Following page: Engineering factory, Willenhall

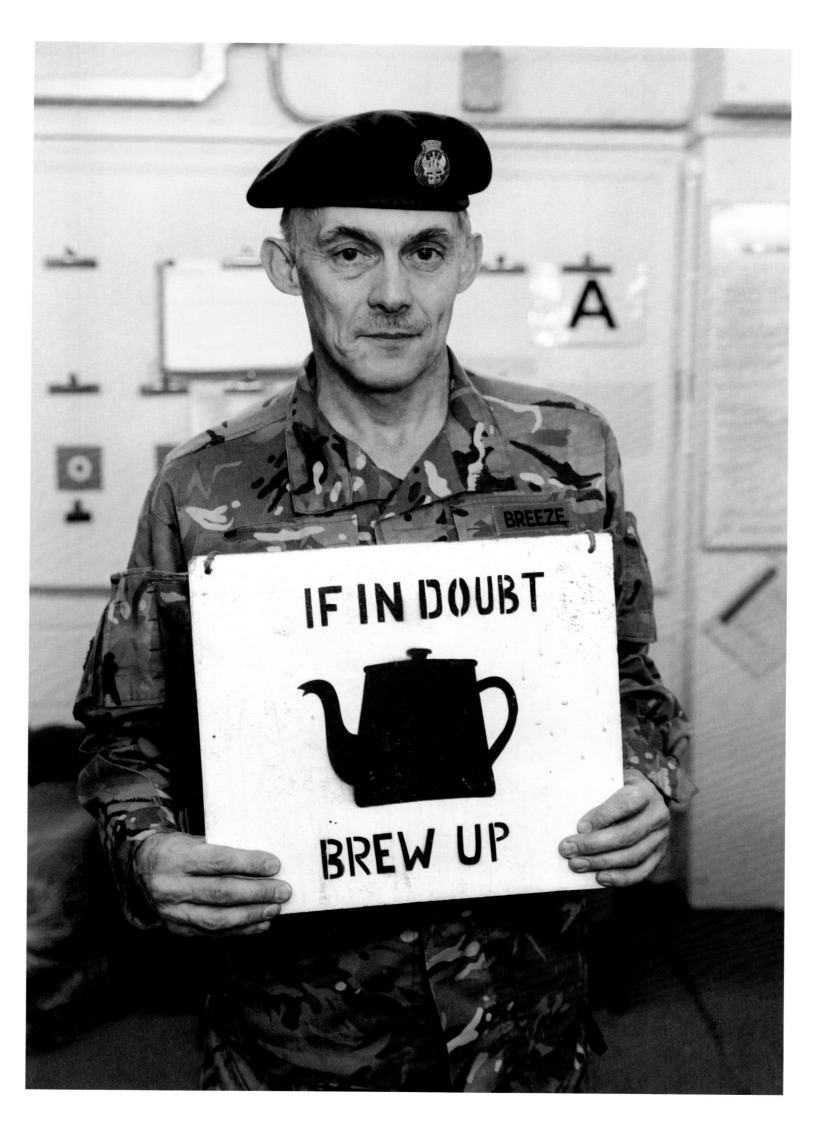

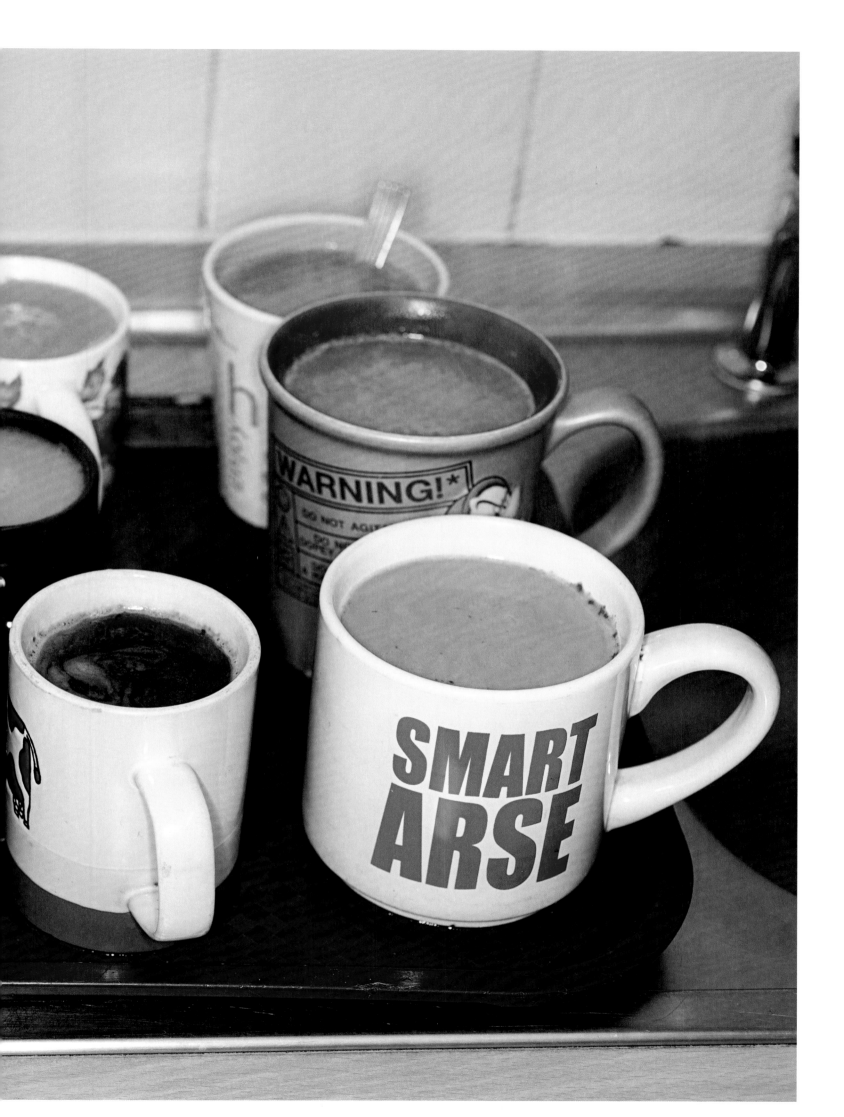

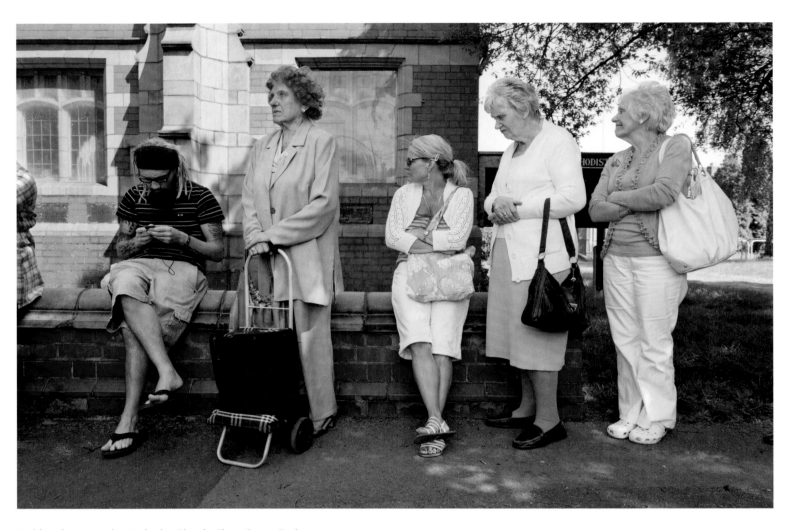

Jumble sale queue, the Methodist Church, Slater Street, Darlaston

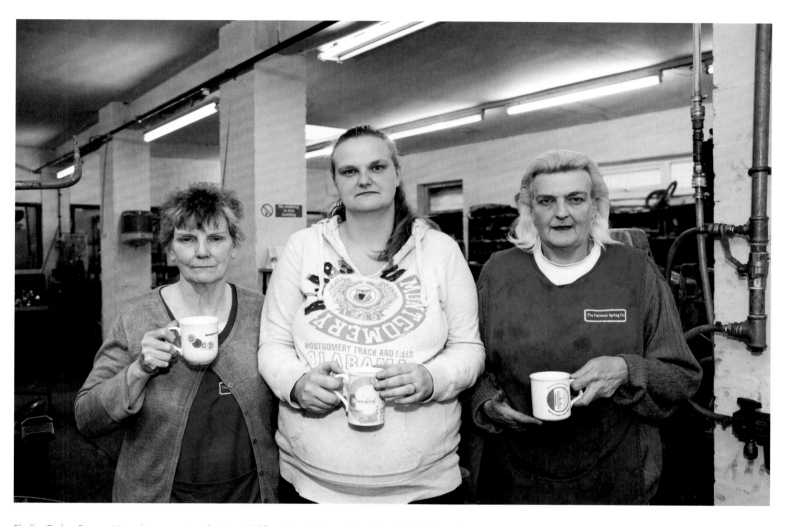

Phyllis Cutler, Donna Wood (pregnant with twins) & Ellen Morris (Donna's mother & Phyllis' sister),
National Spring Company, a spring & metal-working factory, West Bromwich
Following pages: Susan's Hairdressers, West Bromwich / Vicky's Dog Grooming Parlour, Quarry Bank

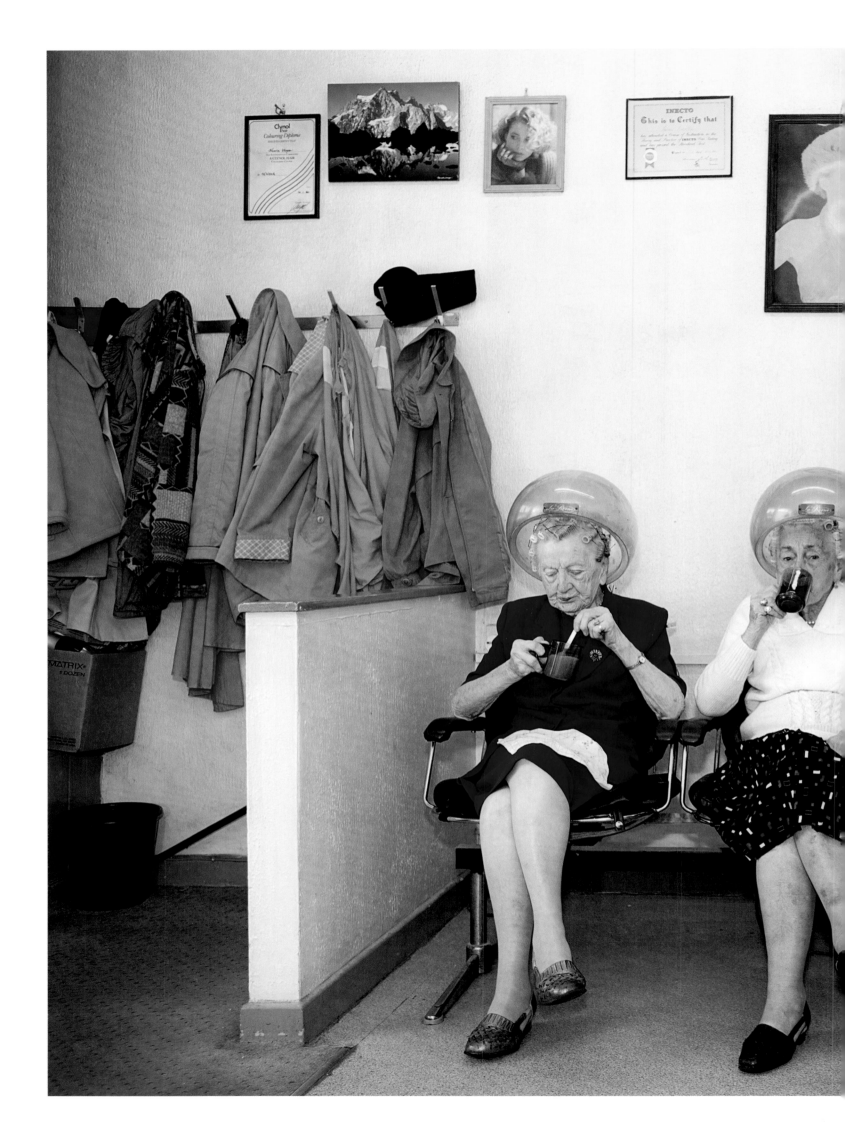

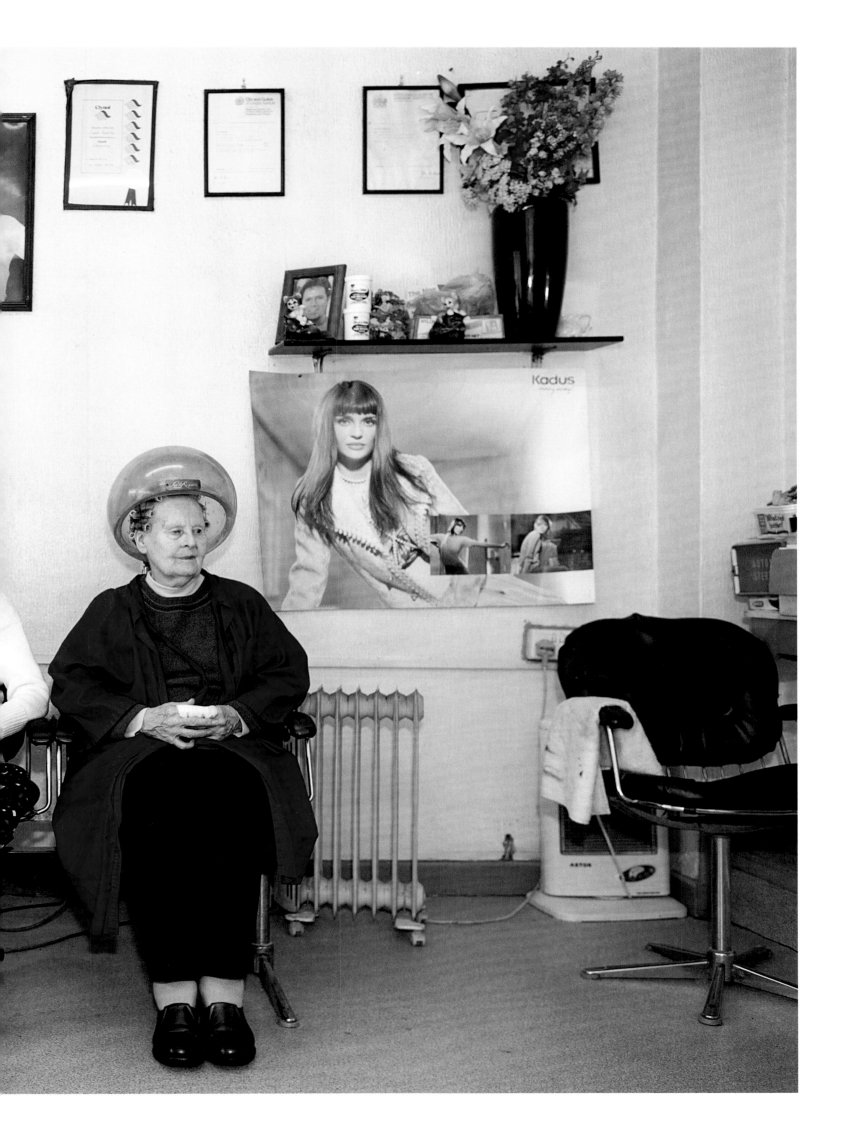

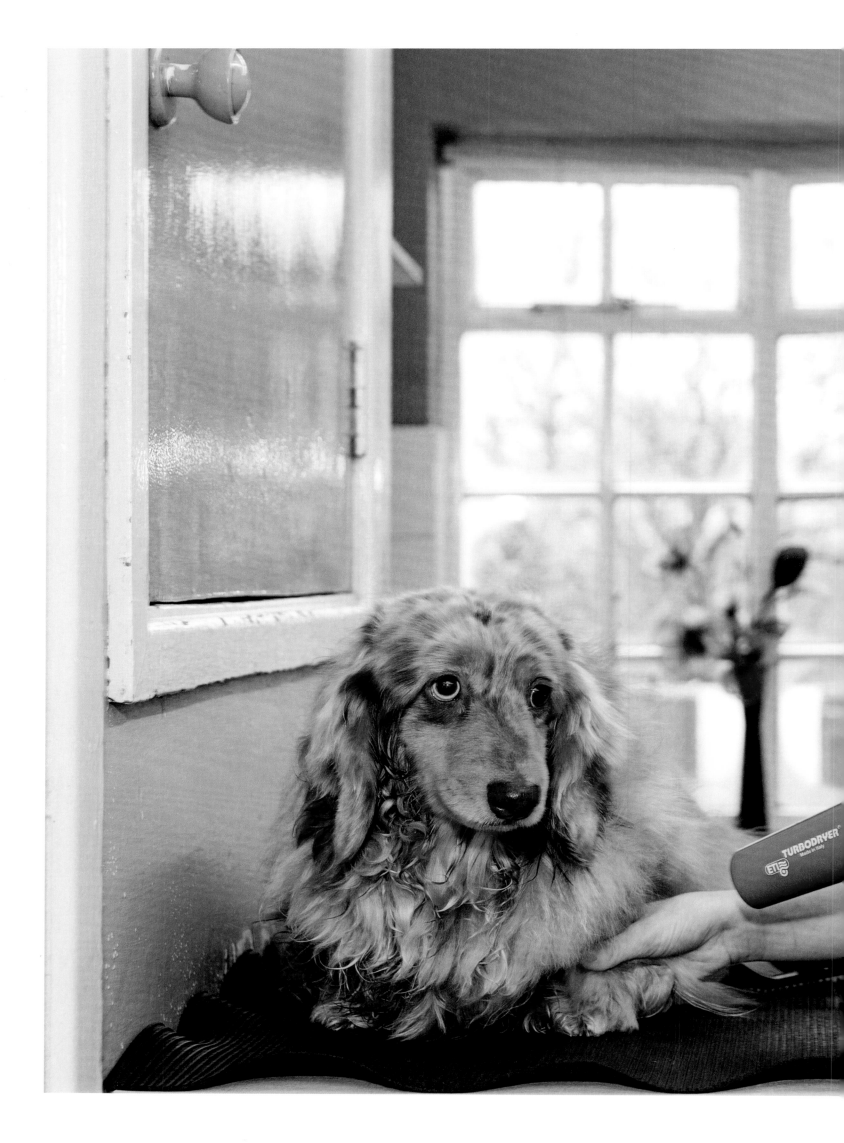

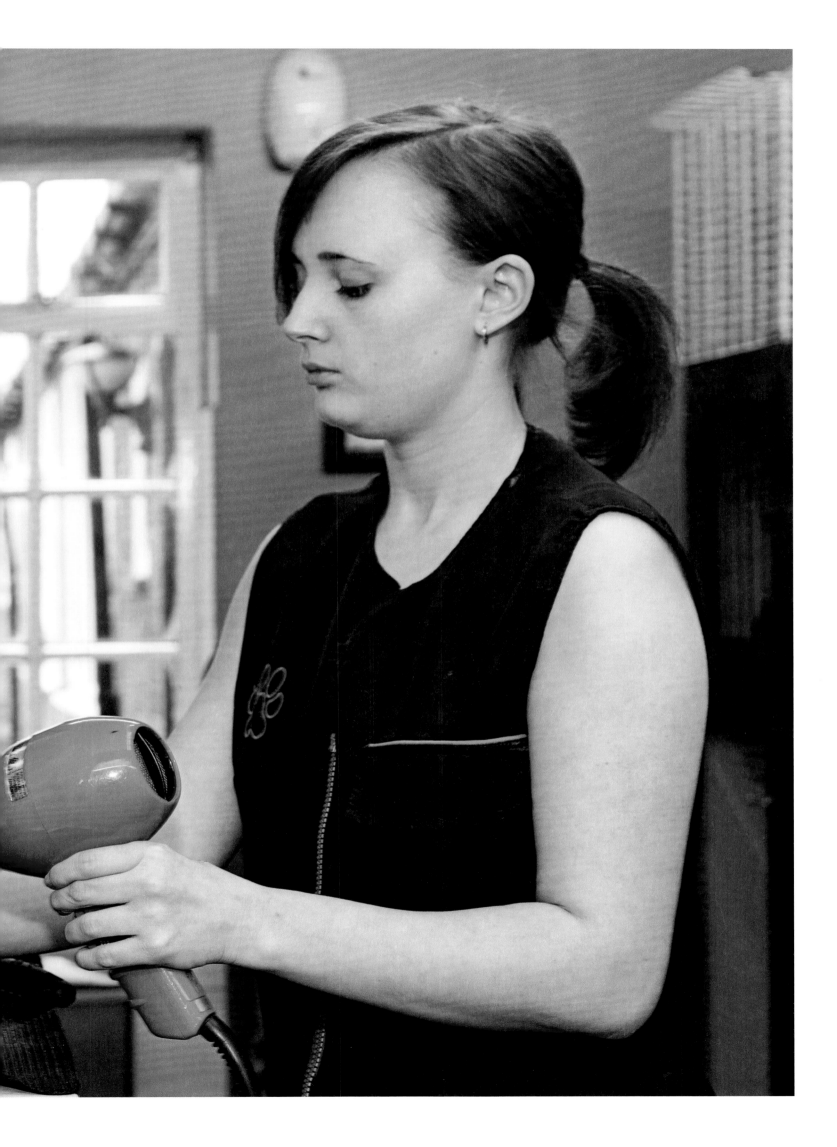

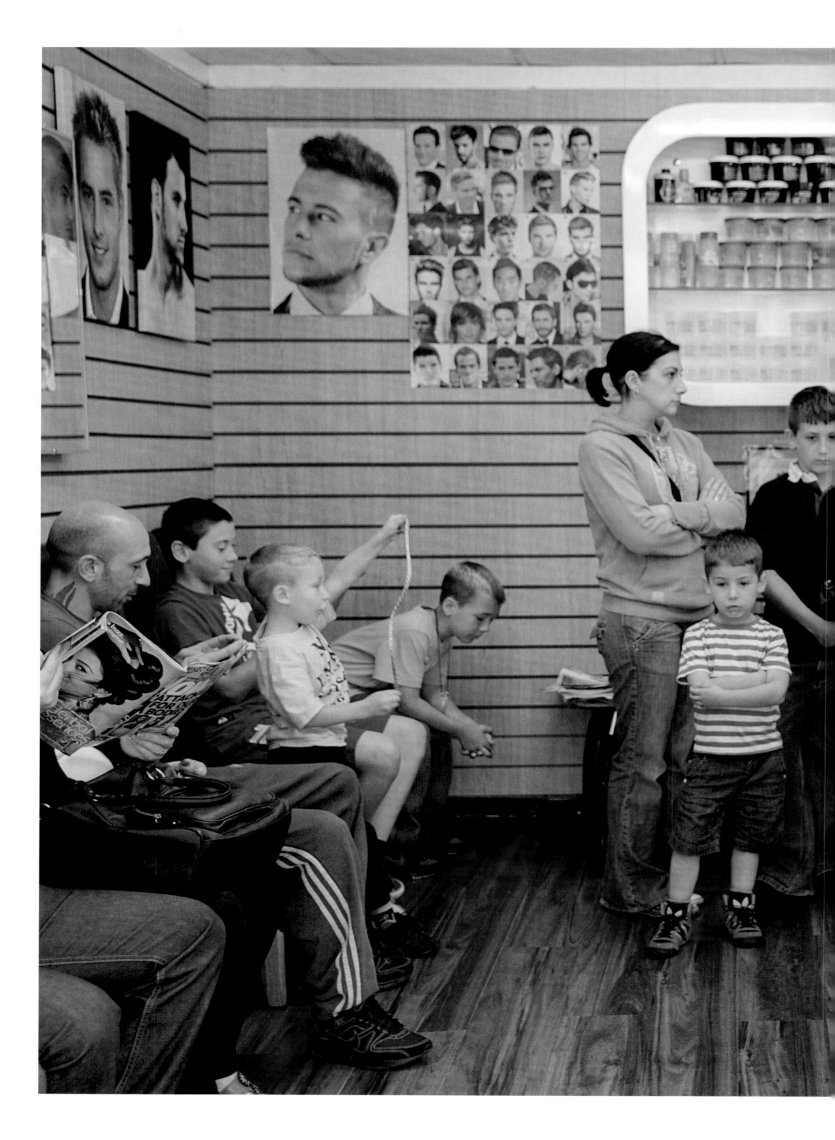

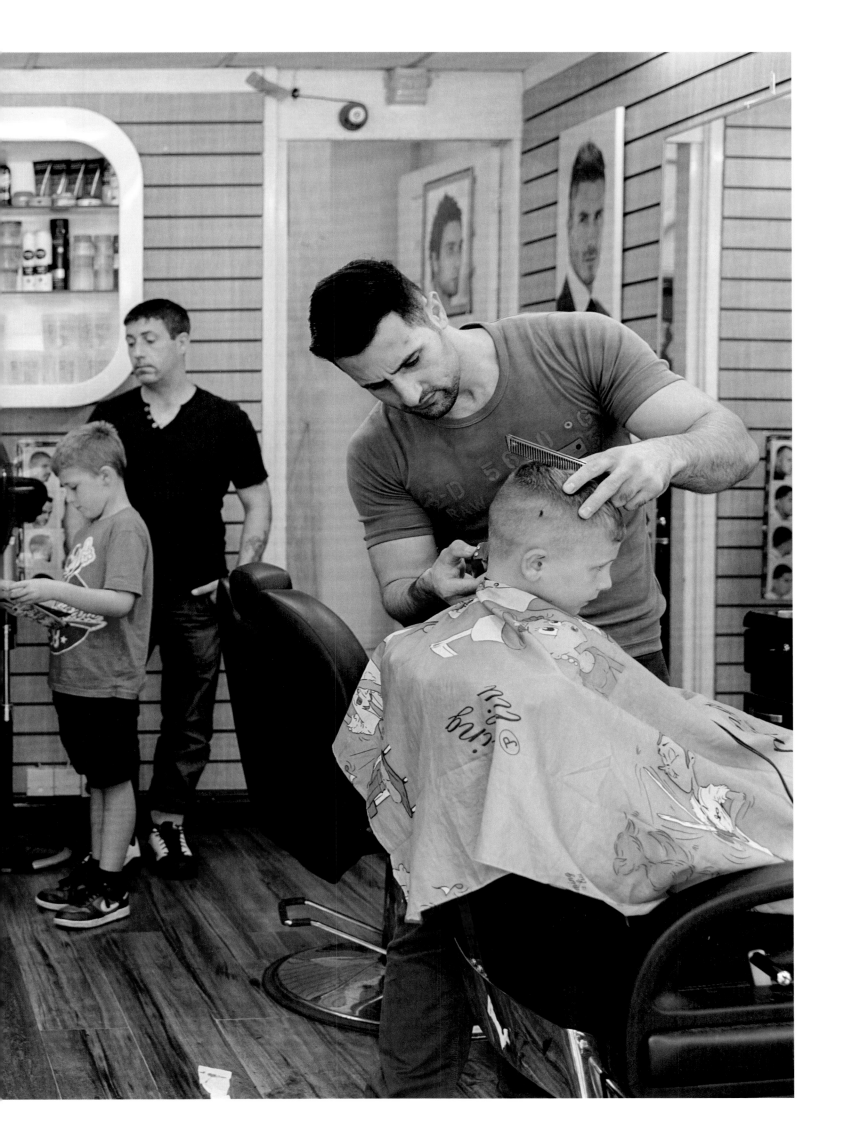

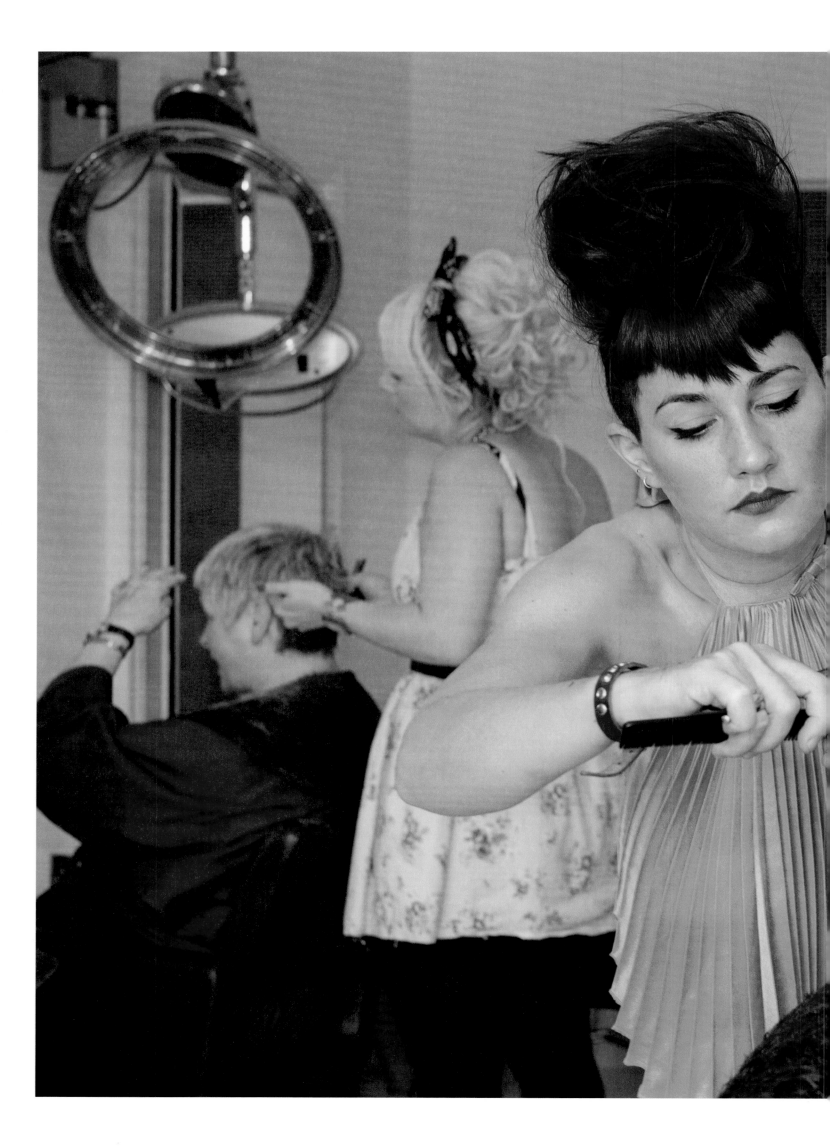

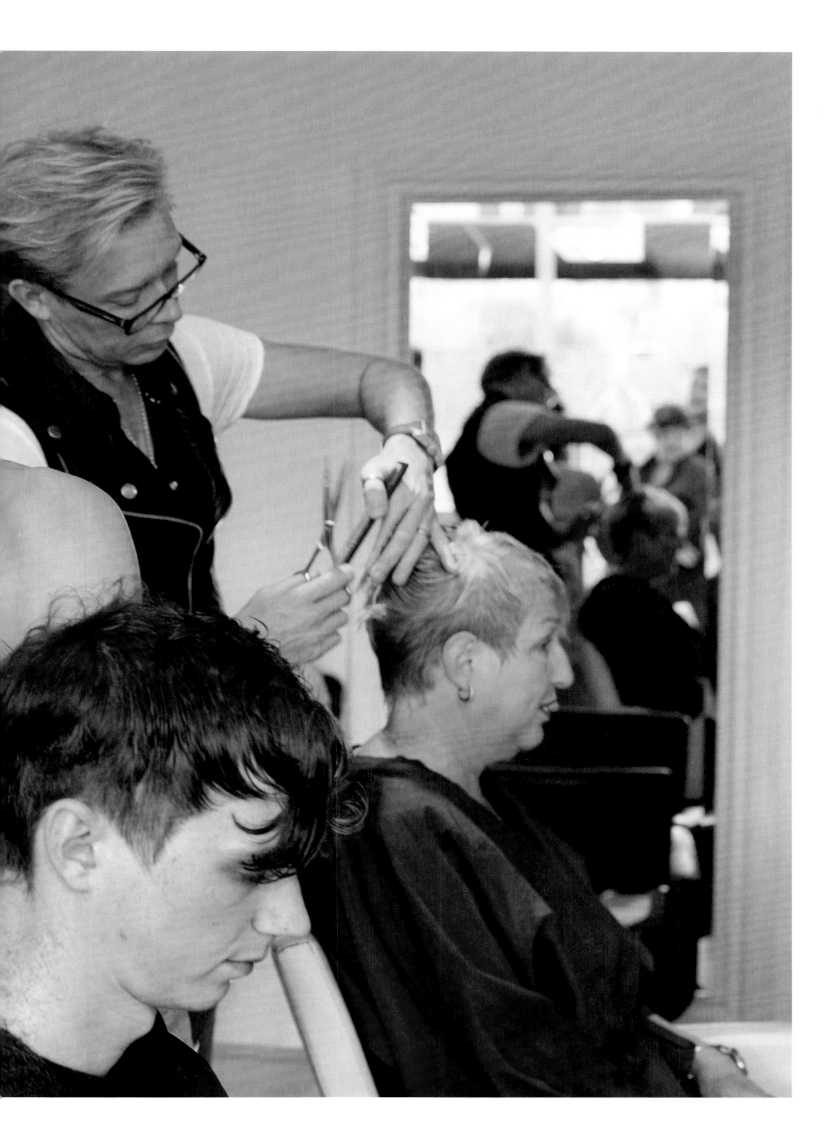

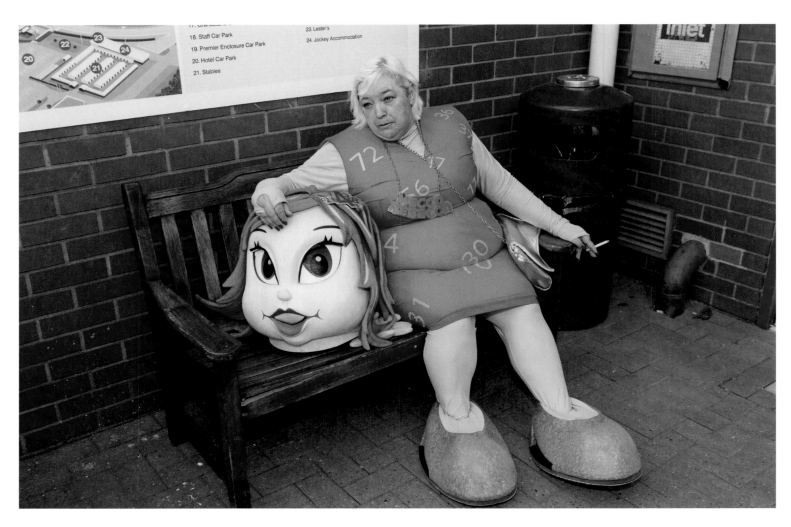

Wolverhampton Racecourse
Previous pages: Hair Style, Brierley Hill, Dudley / Royston Blythe hair salon, Compton, Wolverhampton

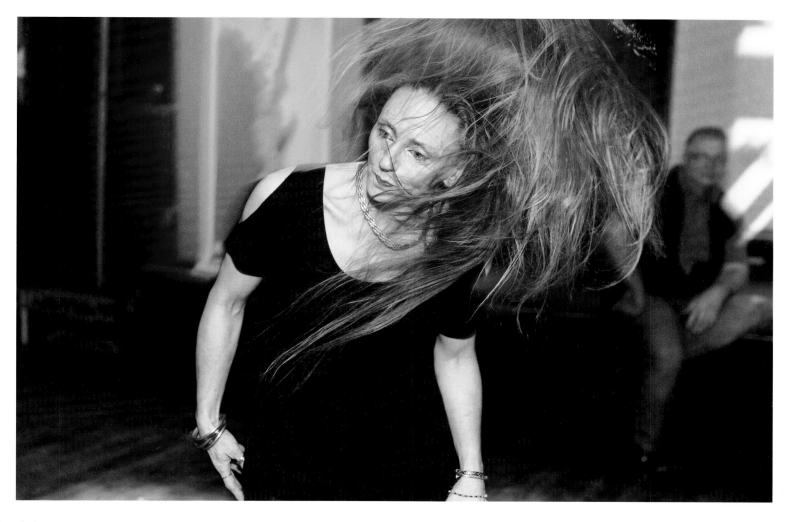

Slade Rooms, Forever Young rock disco, Wolverhampton
Following page: Stourbridge Carnival, Dudley

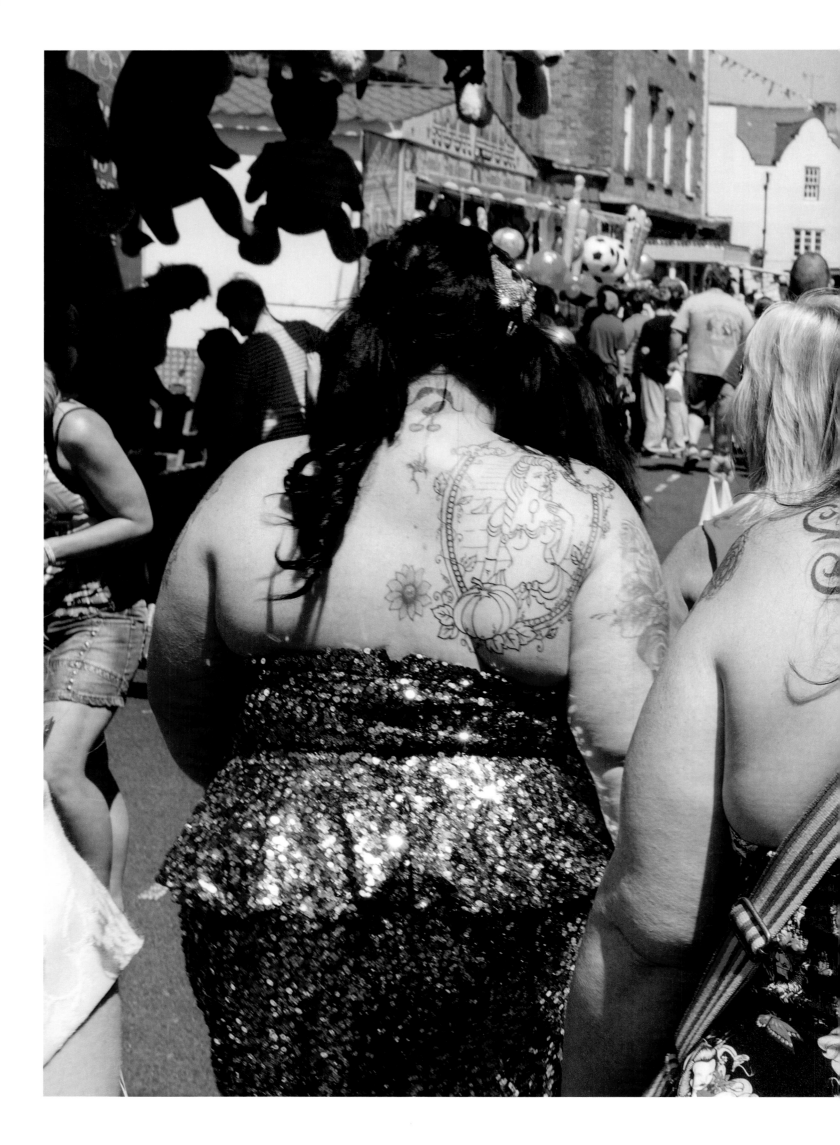

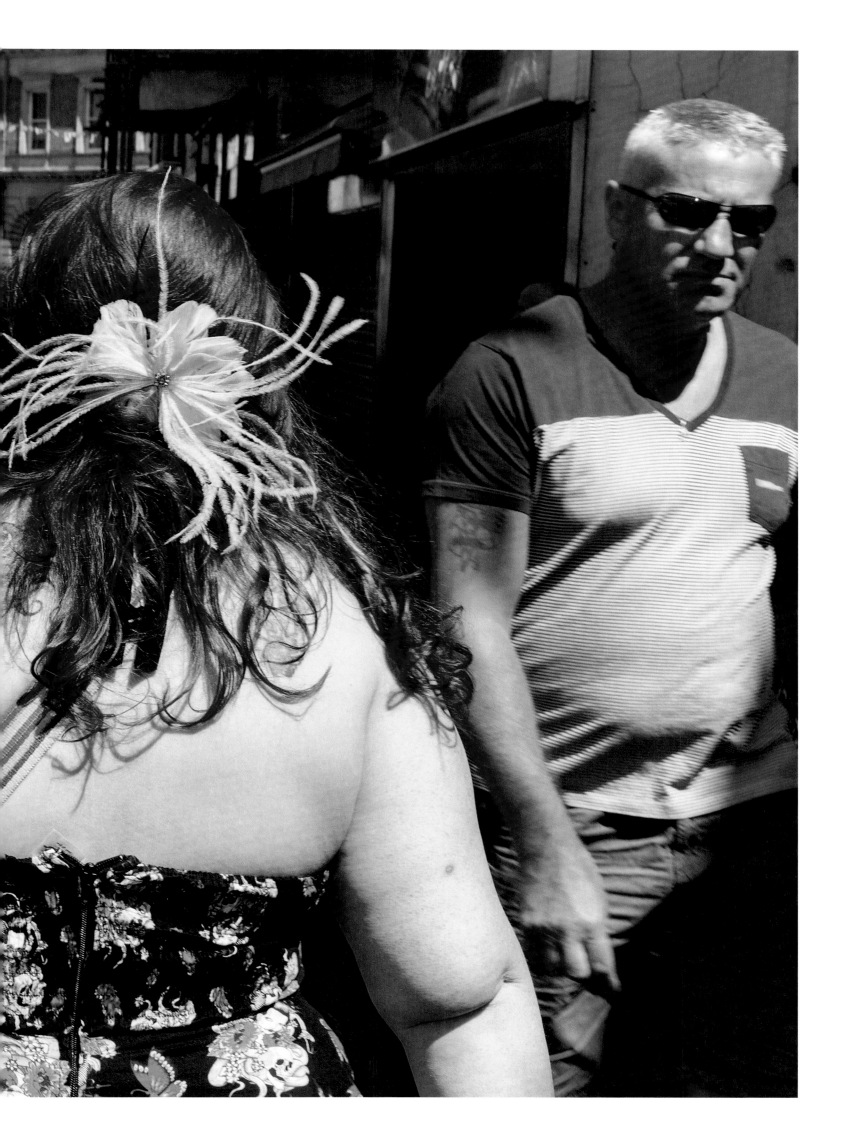

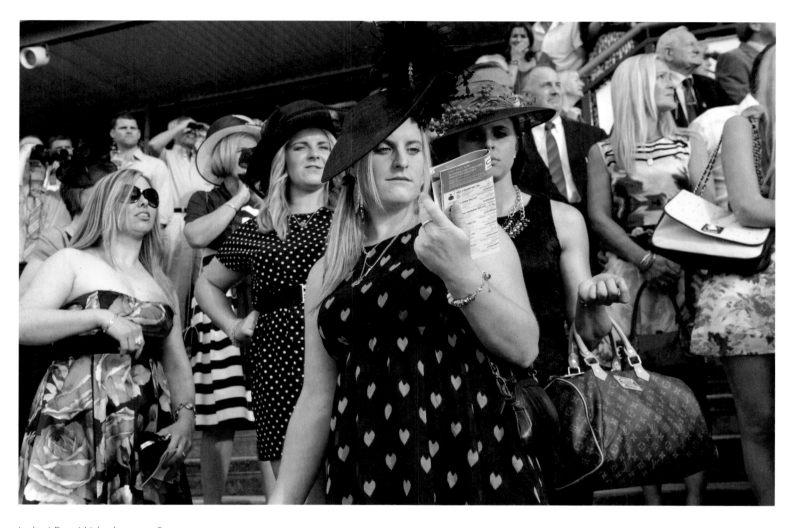

Ladies' Day, Wolverhampton Racecourse

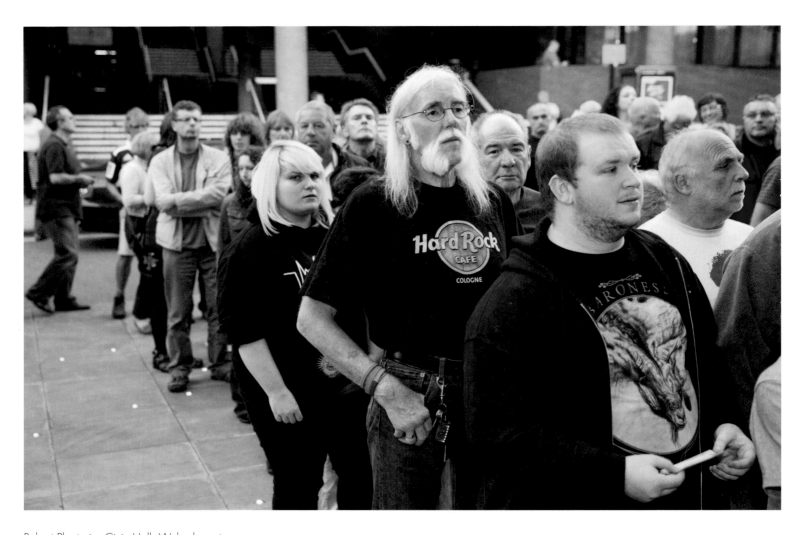

Robert Plant gig, Civic Hall, Wolverhampton

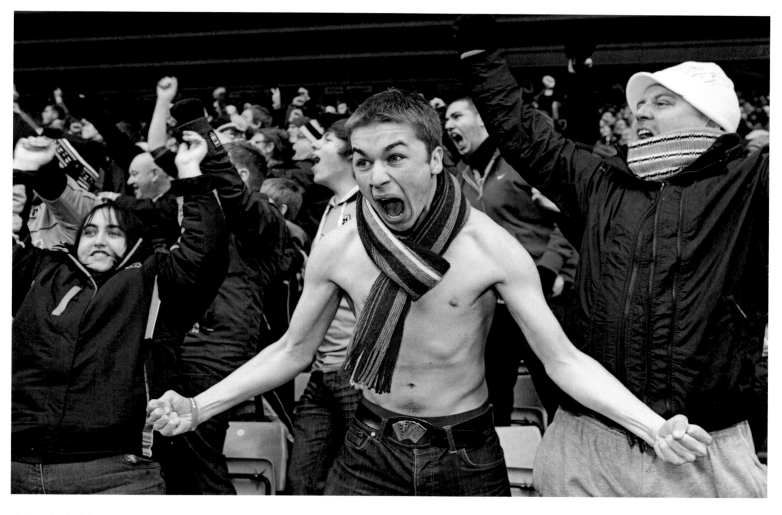

Wolves football fans, Wolverhampton
Following page: Baggies (West Bromwich football fans) leave bags on their seats after a game, Wolverhampton

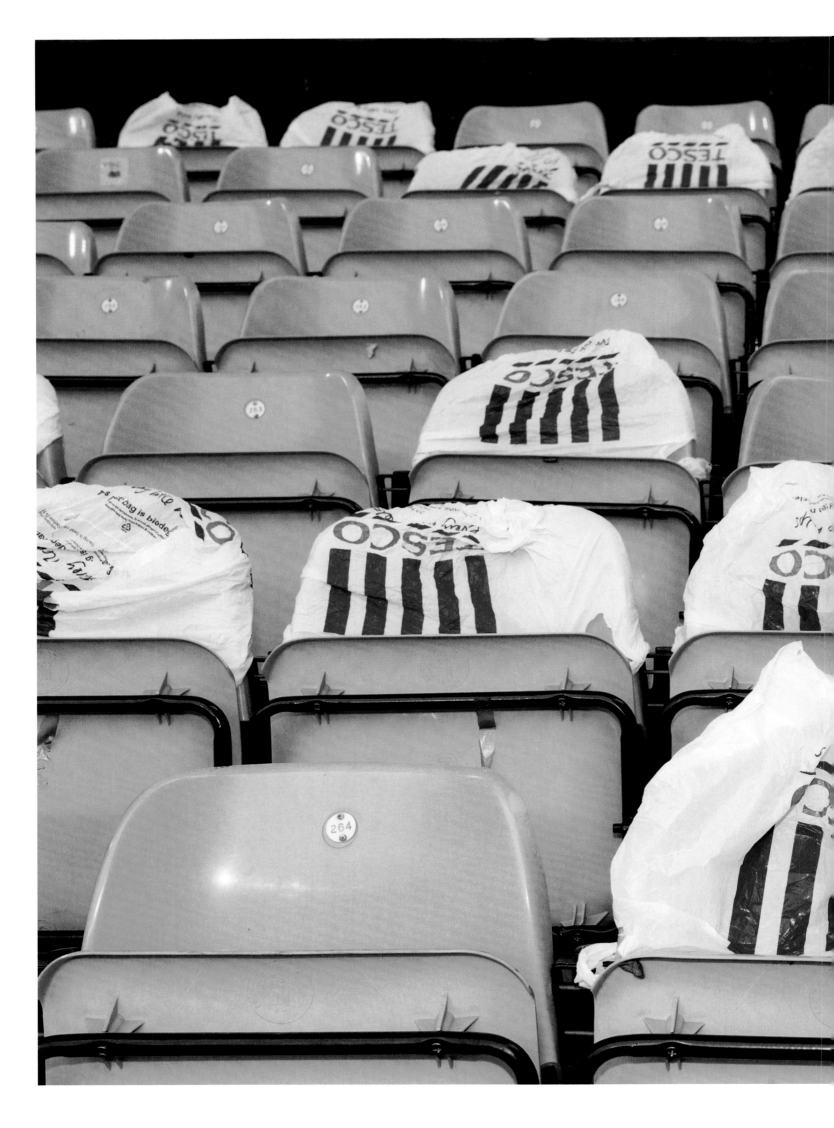

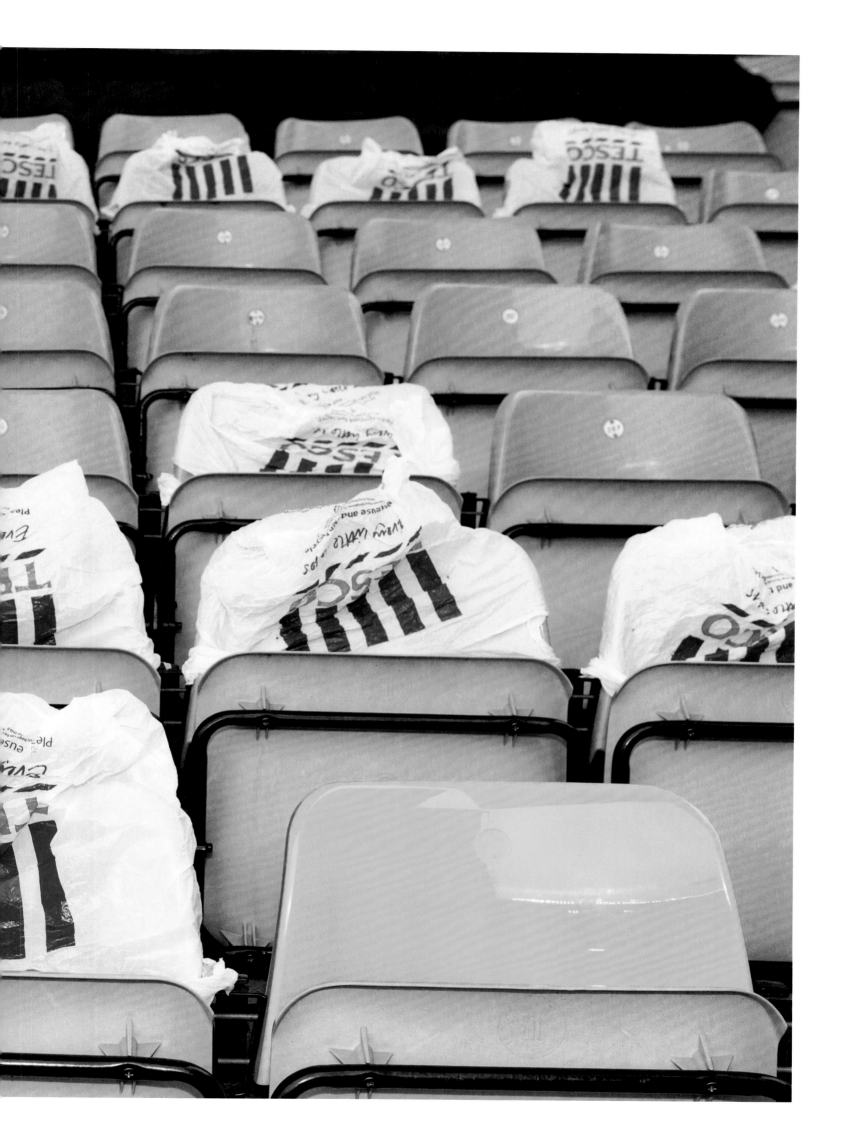

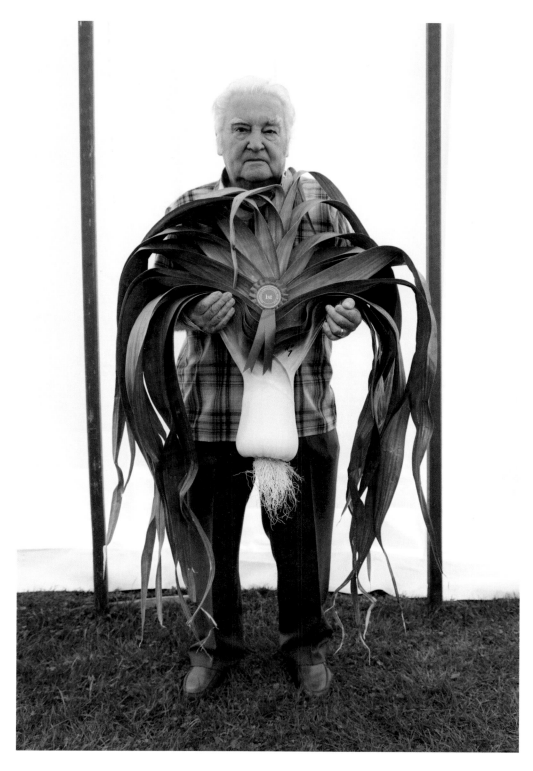

Norman Soper, best pot leek, Sandwell Show

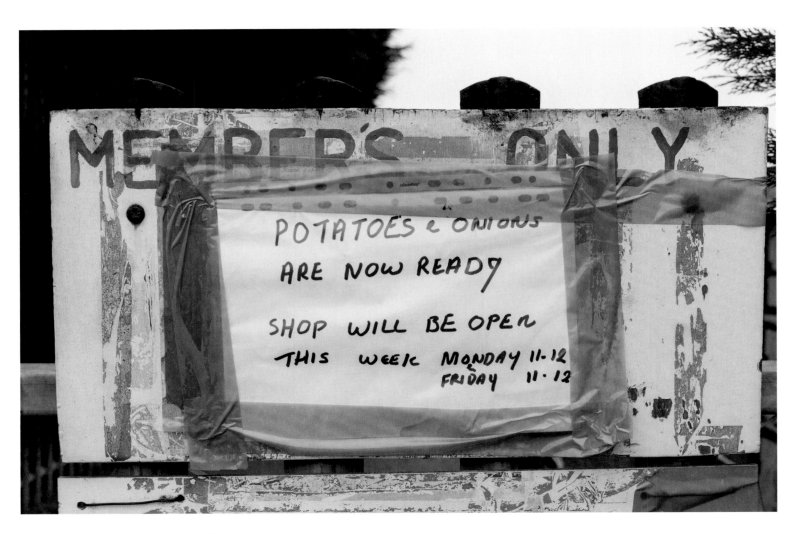

Bromford Lane Allotment, West Bromwich

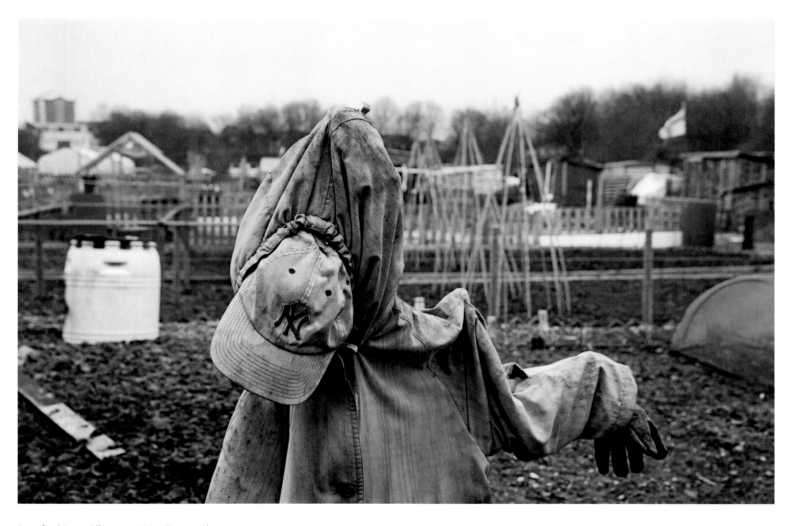

Bromford Lane Allotment, West Bromwich

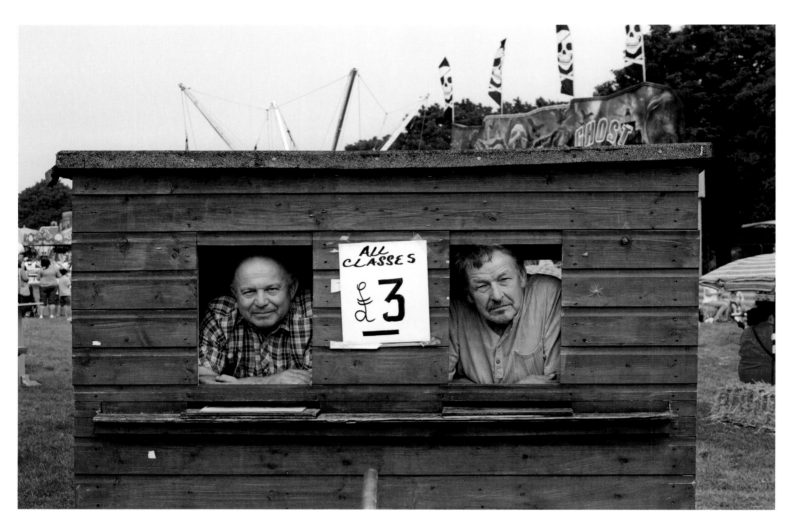

Sandwell Show, West Bromwich

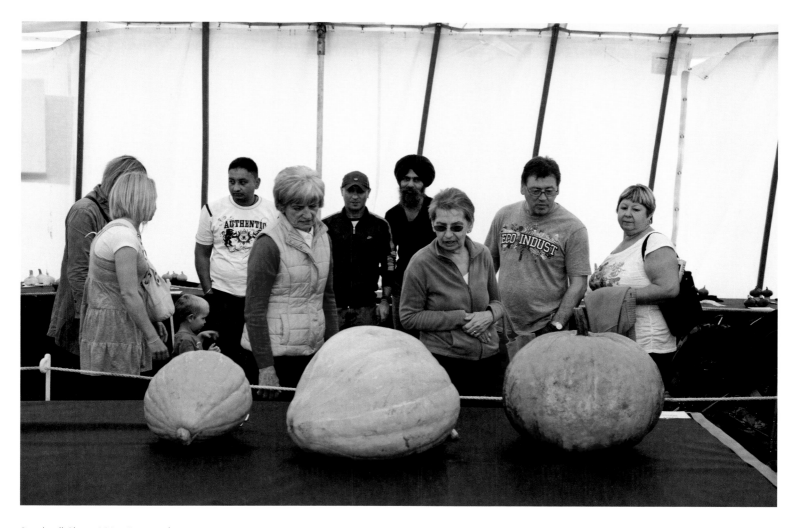

Sandwell Show, West Bromwich

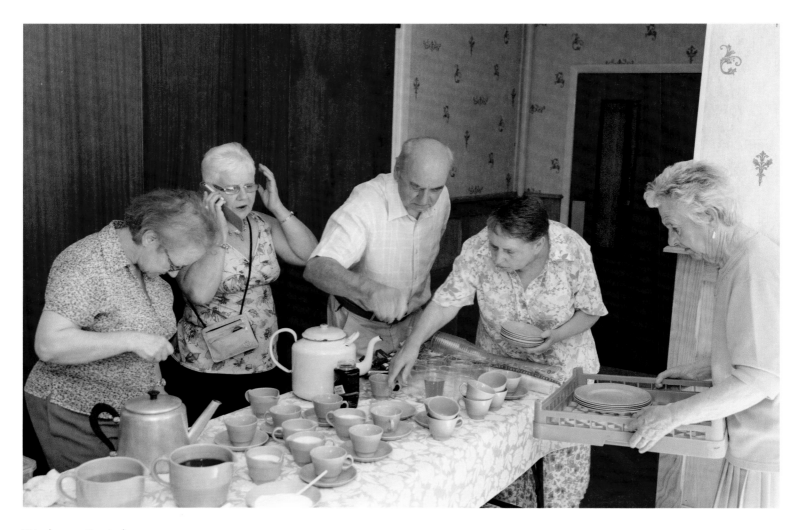

Wombourne Carnival

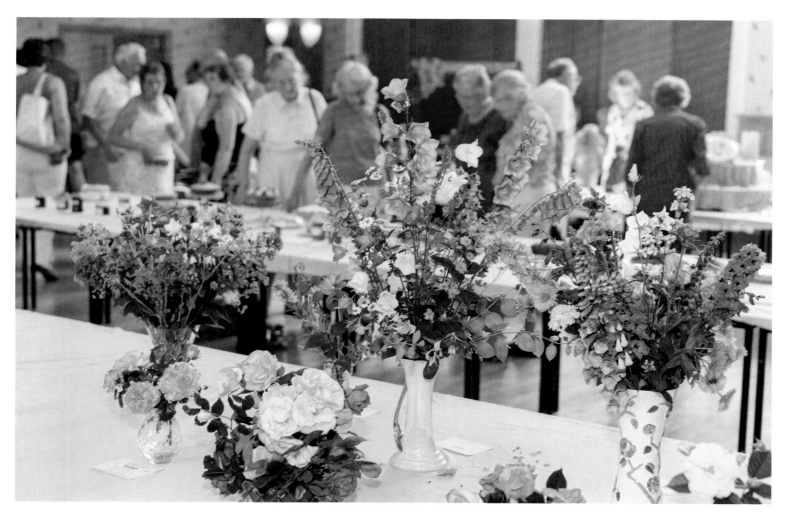

Wombourne Carnival
Following page: Our Lady's Church fête, Wolverhampton

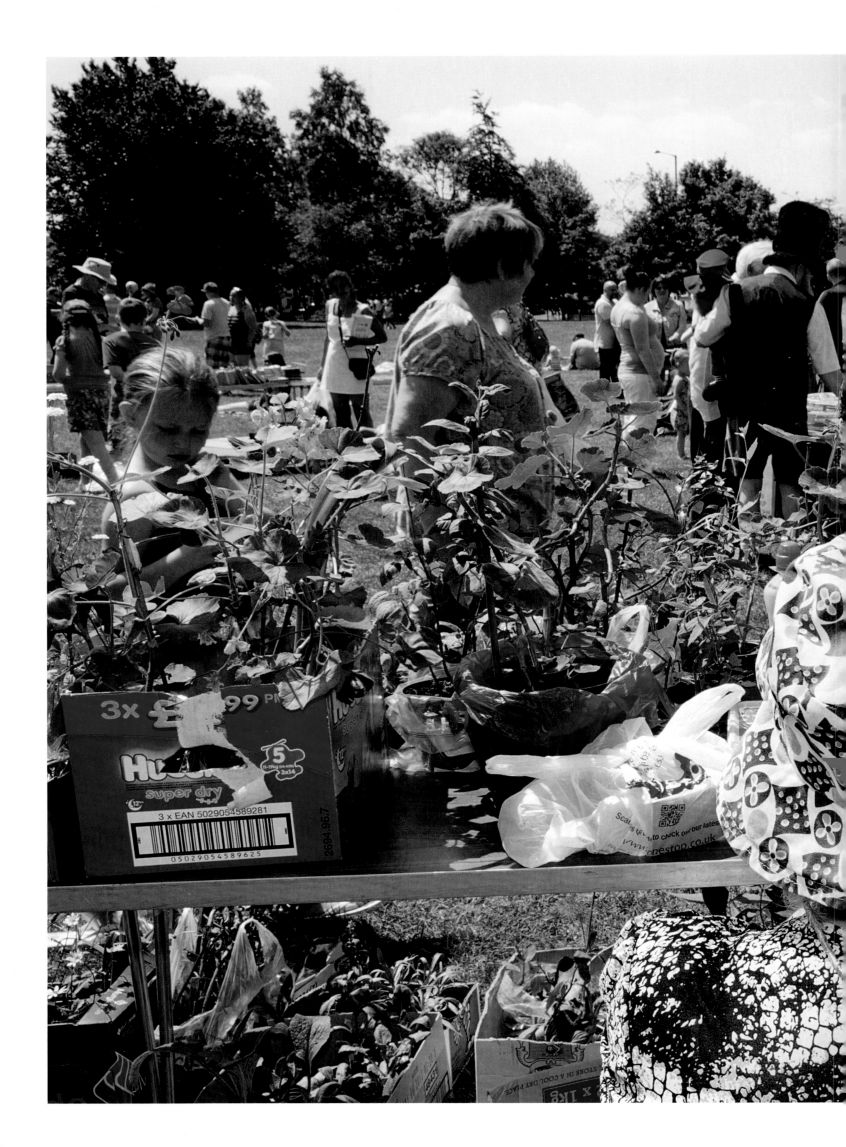

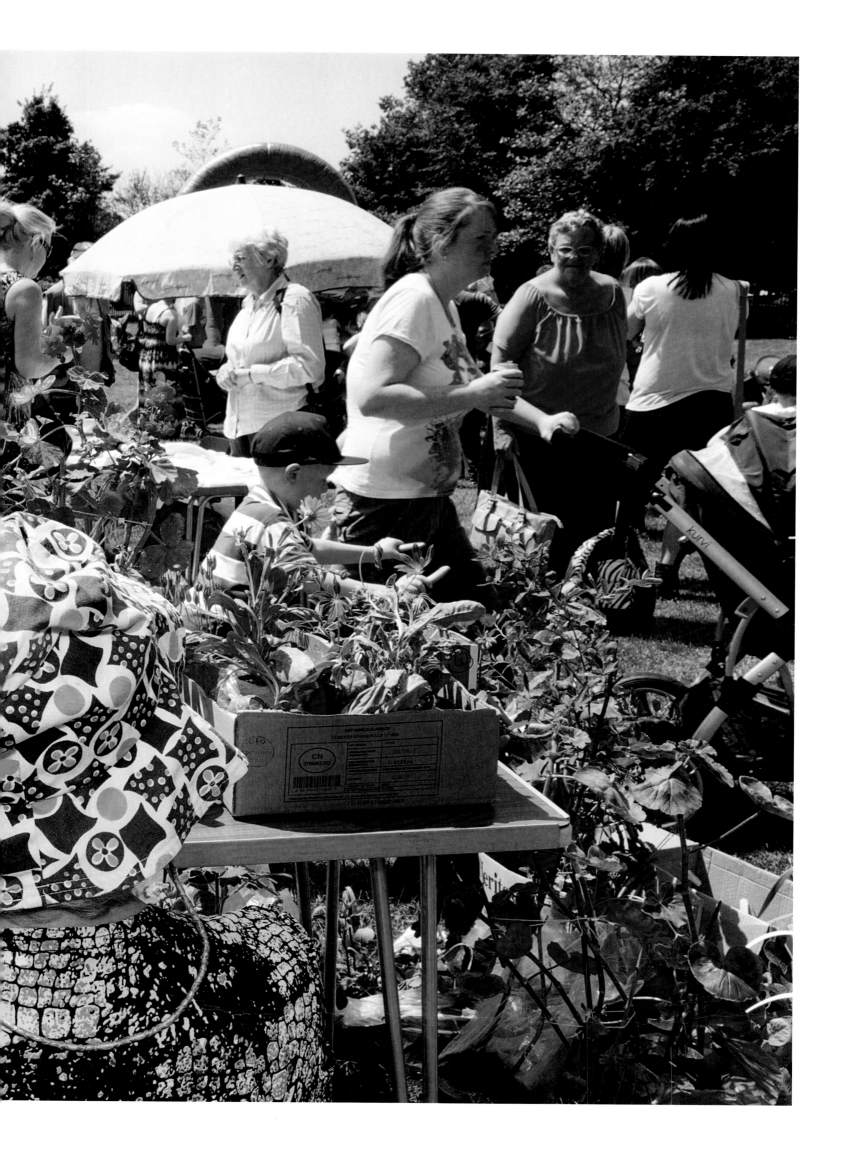

Thank you to the following people who have all contributed to the
Black Country Stories project.

Emma Chetcuti: Director, Multistory
Claire Wearn: Project Associate, Multistory
Caron Wright: Company Manager, Multistory
Graham Peet: Project Associate, Multistory
Jenni Smith: Martin Parr Studio
Tom Groves: Martin Parr Studio
Louis Little: Martin Parr Studio

Stephen Snoddy: Director, The New Art Gallery Walsall
Deborah Robinson: Head of Exhibitions, The New Art Gallery Walsall
Corinne Miller: Head of Culture, Arts and Heritage, Wolverhampton
Art Gallery

A special thank you to all of the individuals, groups, organisations
and companies who have taken part in Black Country Stories; we
could not have done it without you!

First published in the UK in 2014 by
Dewi Lewis Publishing
8 Broomfield Road
Heaton Moor
Stockport SK4 4ND
England

www.dewilewispublishing.com

ISBN: 978-1-907893-63-6

Design: Dewi Lewis Publishing
Print: EBS, Verona, Italy